# As Tom Goes By

*A Tennis Memoir*

## Tom Brown

*with* Lee Tyler

*Tom Brown*

*All best wishes, Ed —*
*Burlingame, Ca,*
*8/3/10*

FITHIAN PRESS, MCKINLEYVILLE, CALIFORNIA, 2007

Published by Fithian Press
A division of Daniel and Daniel, Publishers, Inc.
Post Office Box 2790
McKinleyville, CA 95519
www.danielpublishing.com

Distributed by SCB Distributors (800) 729-6423

LIBRARY OF CONGRESS CATALOGING-IN-PUBLICATION DATA
Brown, Tom, (date)
As Tom goes by : a tennis memoir / by Tom Brown with Lee Tyler.
   p. cm.
ISBN-13: 978-1-56474-465-4 (pbk. : alk. paper)
    1. Brown, Tom, (date) 2 . Tennis players—United States—Biography.
I. Tyler, Lee, (date) II. Title.
GV994.B76A3 2007
796.342092—dc22
[B]
             2006032709

*"…the sentimental things apply…"*

# Contents

*A section of photographs follws page 72*

# Acknowledgments

FOR their various contributions in helping me put this book together, I want to thank my late father, Thomas Pollok Brown, Sr., for his prodigious collection of tennis press clippings; my dear mother, for instilling in me a lifelong hankering to travel; my nephew (more like a brother) Joe E. Brown, a writer himself, who egged me on at an early stage to pursue this project; and my children, Mark, Wendy, Sue, and Sally, for their cheerful support throughout.

I also thank Bud Collins, Ron Fimrite, Ed Baumer, the late Gene Scott, and Don Asher for their early encouragement; Alan Little, Wimbledon's historian; and Gianni Clerici, author of *The Ultimate Tennis Book—500 Years of the Sport* (and a player himself), for nuggets of information about the background of tennis. Thanks also to Dennis Mayer for ongoing computer assistance, and to writer friend Bill Mason for suggesting a way to perk up a certain chapter.

I thank Dr. Charles A. Rockwood, whose skill as a shoulder surgeon got me back on the courts sooner than I had hoped. And a special thanks to friendly opponents, especially John Dalton, Leon Blum, Dennis Huajardo, and Jeff Tsu, for their patience in bearing with me after my knee replacement while I regained some semblance of my game.

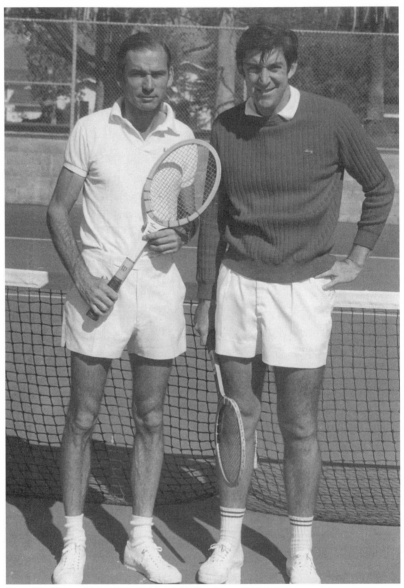
Barry MacKay and I in 1972, Oakland, California.

## Foreword

I FIRST met Tom Brown in New Orleans, Louisiana, during the Christmas holidays of 1956. We were both playing in the Sugar Bowl Tennis Championships, a part of the big Sugar Bowl Football Festival. Tom was one of the top players in the world, and I was an aspiring junior student player at the University of Michigan invited to fill out the draw.

Tom dispatched me in straight sets rather quickly, and I remember walking off the court thinking how often I had looked to my right watching another down-the-line passing shot go just beyond my outstretched forehand volley. His was truly one of the best shots in the game. Little did I realize then how often I would watch that same shot pass me over the next fifty years.

*As Tom Goes By* is a fascinating look at one of the unsung heroes of American tennis in the late forties, fifties, and more importantly on into the 2000s. No one has had a longer and more successful tennis career than Tom Brown.

The story takes you back to Tom's earliest days on the public courts of San Francisco. It moves on to some exciting moments during World War II when Tom was the only army private carrying a tennis racket in an artillery tank!

Having traveled the "Amateur Circuit" for five years myself, I can appreciate the inside look that Tom gives of those glamorous days from Rome to Paris to Monte Carlo. How often people at the parties would ask, "If you're an amateur, how do you make a living?" It was an atmosphere that only a few of the best players in the world enjoyed, and Tom was one of those few.

This book is written in concise, direct, no-extra-motion, to-the-point style, much the same way that Tom has played the game over

the years. It carves out a true history of tennis in the glory days of amateur tennis when Davis Cup, Wimbledon, and the other Grand Slams were only open to amateur players. Only did this change in 1968 when Open Tennis came about. Tom, by then, had moved on to what was becoming one of the most successful senior careers in tennis history.

For the real tennis junkie, Tom's opener, his recall of the 1948 Wimbledon Final at Centre Court, Wimbledon is a classic. The Bob Falkenburg–John Bromwich final is still remembered in tennis circles for its drama, and Tom brings it to you from fifteen feet away.

This book is a beauty, and it tells firsthand Tom's memories throughout a unique career. As a player, I loved it. But if you just want to go on an exciting trip, get ready.

Tom and I go back fifty years now, and I can truly say I have been privileged to know and respect one of the finest men the game of tennis has ever had.

Enjoy!

Barry MacKay
BMK Sports
*July 24, 2006*
*Sausalito, California*

# *First Set*

# 1. Boom Boom

*Centre Court, Wimbledon, England. Summer of 1948*

I WAS STANDING on the pathway leading from the locker room to that famous tennis stage, dressed and ready for play because Gardnar Mulloy and I were in the men's doubles final, the next match to go on.

Just a few feet away from me, Bob Falkenburg of Southern California and John Bromwich of Australia were battling for the men's singles title. Bromwich was leading, 5–2 in the fifth.

John, whom I had known as a Davis Cup opponent in 1946, had a very strange game. He was left-handed but would hit a two-handed backhand off his right side, and forehands from his left side. He would serve and smash right-handed, but handle lobs with that weird left-handed forehand. And he was like a bulldog; he didn't believe in missing a shot.

At 2–5 in the fifth set, match game for Bromwich, you would have thought Falkenburg was through, but besides having a superb sense of judgment in terms of his own abilities and in analyzing plans of the other player, Bob had an iron will and a sureness of feel. He also had a good deal of luck.

It was now Falkenburg's serve, and I witnessed a fantastic match turnaround. The way Bob won points was to try to serve hard, hit a short ball, and hit the next one kind of deep. Bromwich fell for it—ran in, thinking Falkenburg would do the same. But Falkenburg had the advantage of being on serve. And what a serve! His first was a cannonball, a hard flat serve with which he could serve aces or force Bromwich to hit a short ball and miss it.

The second serve he could hit with a heavy topspin which would strike the court and jump up and forward.

Now, Bromwich was extremely steady and sharp on passing shots, but Falkenburg was very tall (6 foot 3½ inches), had very long arms, and could reach practically anything. So Bob held his serve, and it was 3–5, Bromwich still leading.

They played close points, which would go back and forth to deuce. All of a sudden Falkenburg decided that now was the time if ever he was to pull it out. He went in—and though it wasn't as good an approach shot as he would have liked, he figured on Bromwich, what with the pressure and everything, hitting it back within reach so he could volley it, put one or two back together, and eventually break Bromwich's serve.

It was interesting and intense to watch. Bromwich had one or two point matches, on one of which he served a double fault, which was manna from heaven for Falkenburg.

Then they had a rally. Pretty steady, just back and forth, over and over with neither of them having a particular advantage. Then came a ball short enough for Bromwich to start running in.

Well, Falkenburg did not have sensational passing shots in his repertoire, so what he did was to take the ball and send it right back down the center of the court, straight at Bromwich. The volleys went boom-boom-*boom!* And the last boom was Falkenburg's and he hit it for a winner. That made it deuce.

Then Bromwich served, and it got up to his advantage again, another point match. And what did he do? He served a double fault. Falkenburg managed to win the game and it was now 4–5. Falkenburg pulled up even and it was 5 all. And then Bob played a very good, close game and broke Bromwich's serve to go ahead 6–5.

They changed sides. As they did this, Falkenburg took an extra drink of water, and an extra bit of time toweling off so that his racket hand would not be slippery. He walked over slowly to serve. Took his time; adjusted his position, reared back and aimed the ball.

And I just knew what was going to happen. To this day, it is spectacular in my mind. I knew what he was thinking, because I'd been

there myself, just one year earlier. "I'm in the finals at Wimbledon. This is the biggest tournament in the world. I am never going to be at a higher pinnacle than I am now. If I am ever going to play well to win a match, I must do it now, because I'm never again going to have a chance like this. And the only thing I can win on is my serve. Bromwich is too strong off the ground for me. If I get into a slogging round with him, he'll nose me out of it, wear me down, and beat the hell out of me."

And so Falkenburg set about serving. He measured the ball—sort of pointed his racket along his sight line, reared back, and bang, bang, bang, *bang!* He served four aces and won Wimbledon. It was sensational. He threw the racket about forty feet up in the air, ran to the net, and hopped over it.

I knew he was going to go for those big shots. Nobody in the world who has ever been to Wimbledon, not even Bjorn Borg or Jack Kramer, would have been able to get any of those balls back. Because grass is fast, and the balls were four bullets. Bob went for the backhand, and he went for the forehand, and he placed all four shots in the corners of the service court. It was beautiful.

Falkenburg was also a very good bridge player, a hard thinker, just the way he was at tennis. He would review the situation, figure out what was likely, and take chances. He would hold his emotions under key, never give himself away.

Nineteen forty-eight was my third competitive year at Wimbledon. I was twenty-five. Still on a high after my exhilarating debut two years before, when I nearly got into the men's finals and *did* win both the men's doubles and mixed doubles. And still relishing my race into the men's finals in '47, knocking out old friends and foes and Wimbledon's defending champ along the way. Quite an accomplishment for a public court kid from Golden Gate Park, San Francisco!

I brought my mother to Wimbledon in '48, and every night she, Bob, and I would play bridge. Falkenburg was glad to have this escape, because young girls were always chasing him, he was so damn good looking.

## 2. Mr. Lonesome

AS TIMES GO BY, I find that my life memories are a heck of a lot sharper than where I put my glasses.

I was a Depression baby, born September 26, 1922 in Washington, D.C. My father, Thomas Pollok Brown, was a newspaper man from California who'd gone to Washington to be a correspondent for the *Sacramento Bee* and other papers. He was itching to get back to the West.

Dad was born in Cincinnati, Ohio. His father, LeRoy D. Brown, was a dedicated teacher who, when only thirty-four, was elected head of the Ohio state school system. At age thirty-eight, LeRoy received an offer he couldn't refuse—to be president of the brand new University of Nevada. And so the family of seven (wife, Esther, plus five small children) moved to Reno.

For health reasons, LeRoy resigned after three years on the job and resettled the family in Santa Monica, California. There, on a vacant lot next to his house, he built a clay tennis court for the amusement of his children. Great idea! My dad, then eleven, became tennis pals with the boy next door. His name was Tom, too; last name Bundy.

My mother, Hilda Jane Fisher, was a farmer's daughter, born in San Jose, California. Like dad, she'd gone East to find work. She and dad met as blind dates. She was his second wife. They had a daughter but the baby died at two months. My being born was their impetus for coming out West again, where they felt they belonged.

Since it was hard to look for a job long-distance, Dad came on

ahead, and Mother and I followed by train. I was two years old. To this day, I feel sure that this early trip instilled in me a lifelong fondness for travel. I've always liked the sound of train whistles and the feeling of being in motion.

My mother's parents owned a ranch in Merced, and since it offered free housing that's where mother and I lived at first. As toddlers will do, I managed to get into trouble soon after arrival, impaling my right hand on a pitchfork. I'm told I was white as a sheet as blood gushed from a broken artery. But medical help was close by, and that hand was to serve me well—excuse the pun—the rest of my life.

It was only a month or so before Dad sent for us. He'd found a job as publicity director for the Western Pacific Railroad and an apartment for us on Fifteenth Street in San Francisco, within easy streetcar range of Golden Gate Park. It had tennis courts, he told mother. It would be good exercise for us.

I grew up fast. I was a happy boy. A photogenic kid. My dad was not averse to offering me to his public relations chums for photo shoots promoting such civic awareness as "Do your Christmas mailing early." At three, I was posed trying to shove an impossibly big box into a little mail slot. It made all the San Francisco papers.

I was a good student. Walked to school. Liked all my subjects except singing (which was a bona fide subject in those days!). I still have my original civics card, pledging "quietness in the halls and cafeteria, politeness to all, and making no particular odors in the building."

I was somewhat lonesome, though. I'd have liked to have had a brother or sister like all the other kids seemed to have, but it wasn't to be. I did have a half-brother, LeRoy Dorland Brown, my father's son from his first marriage, but LeRoy, named for my grandfather, was twenty-two years older than I, too much of an age spread to pal around with, and besides, he lived all his life in Southern California.

LeRoy's stepfather was my dad's brother, Joseph Gabel Brown. A little confusing, wouldn't you say? LeRoy had several children. One

of whom, a boy named Joe, grew up to be a writer and many years later became my favorite nephew, although, in actual age, there were only seven years between us.

But back to my own childhood. I didn't have many pals, nor did I go out for baseball, football, or other boyish things. I did enjoy splashing around at Sutro Baths, a fantastic heated indoor saltwater swimming pool back of the famous Cliff House restaurant beside the Pacific Ocean.

There was a sea cave beneath the Cliff House that a friend and I explored one winter day. The tide was out when we climbed inside but we found ourselves stranded when the tide rushed in. The Coast Guard rescued us, hauling us up the cliffside by ropes. That escapade made the front pages, much to my parents' chagrin. "Coast Guard Saves Trapped Boys," screamed the headline. It was my first press clip.

What I most enjoyed was satisfying my wanderlust by riding around on San Francisco streetcars. Since Dad often worked late, and Mother by now was busy with two jobs so she could study to be a teacher, I had a lot of time on my hands. It was safe for a child to go solo adventuring in those days. For twenty cents, I'd get on and ride to the end of the line—all the lines—and I got to know the city very well.

Then I graduated to trains. Dad had a pass for the Western Pacific that could be used by his family. Boy, did I use that! I'd go down to the Ferry Building, flash Dad's pass, go through the gate and onto a ferry across San Francisco Bay to Oakland, where I'd board a train going anywhere. That's how I learned to read timetables and figure out how far I could go and still get home in time for supper. Those excursions were fine with my parents.

The three of us really only saw each other weekends. When I was about eight, I tagged along one day to Golden Gate Park, curious to watch them play tennis. Even as a boy, I was awed by the layout. Twenty-three courts, with men and women all over the place dashing about in their long skirts and long pants, with rackets in their

hands, batting a ball back and forth. Hardly any kids. This puzzled me because it didn't look like a difficult game.

I found a ball, borrowed a racket, and started banging it around on a far court, getting the feel of the thing. Felt good! So I got in a new habit after school of going out to the courts and just kind of hanging out, knocking the ball back and forth with my buddies. One of these boys I still enjoy hitting with seventy years later. That would be Ted Myers. He went on to become a noted physician, who turned his skills after retirement to improving medical care conditions in the third world.

Back to the past. Every now and then I'd pester my mother for a game. "Not yet, dear," she'd tell me. "You're not good enough."

Finally she did agree to play me one set, and she whopped me 6–2. Now, little boys are kind of macho. That was way back in 1930, but I'll never forget that score!

So I became hooked on tennis—on learning it, perfecting it, with the idea of besting my mother at a challenge match. That was my early goal.

I started playing at Mission Playground, a quicker walk from home than the park, and soon became their tennis champion. There'd be various citywide championships for children and I'd play in them, too, and win.

My dad loved tennis, but was never good at it that I could see. He challenged a ten-year-old boy once, and in trying to scramble to get to a ball, he tore a ligament in his knee which crippled him. He never recovered sufficiently to play tennis again. Sad to confess, I was the boy.

So I started seeking out more agile, better players, boys older than I, at Golden Gate Park. At age eleven, when I was at Lowell High School and captain of the tennis team, I won my first significant tournament. It was at a municipal playground in the Richmond District, out around Twenty-fifth Avenue, a city championship in four junior age groups sponsored by the *San Francisco Call-Bulletin* newspaper. I was elated to win Class 1, for age eleven and under. (I

still have the trophy, a precious possession.) This made me an instant "established player," and I was invited along with the other San Francisco winners to journey sixteen miles down the Peninsula to Washington Park in Burlingame, to compete against the best junior players of San Mateo County.

Our team, San Francisco, won, and my appetite was whetted for more. I remember my first significant loss, to Jack Joost, perennial winner of the fifteens and under (which all went down the drain when he turned sixteen). My first "big" win was over Larry Dee, when he was the second- or third-ranked junior player in the U.S.

I soon realized that to become more consistent I needed some tennis lessons. But there wasn't money to spare for such frivolities. It was the Depression, remember. My father had been put on half-pay and my mother had gone back to college so she could get a teaching degree and help support our little household. We had to move to a cheaper apartment, out on Alpine Terrace.

Solution? I became a ballboy in exchange for lessons at the California Tennis Club. The pro was Howard Kinsey, then nationally ranked number four in singles. Howard was pretty heavy and didn't like to lean over to pick up balls. I was happy to do that for him. Although I took a few lessons from him, I mostly learned by watching notable players who'd drop by—Bill Tilden, Fred Perry, and such.

My most inspiring models were Donald Budge and Frank Kovacs. (Little did I dream that less than ten years later Don and I would become good friends, playing buddies, and dinner companions, just the two of us, once a week or so.) Whatever Don or Frank hit in a certain way that I liked, be it backhand, volley, or serve, I would copy it. Like as not, it worked for me only a short while, and then out it went.

The pattern of play that prevailed then was western grips with the hand wrapped well around the racket. Backhands were weak in those days, but Budge and Kovacs had beautiful ones.

So did some of the juniors I played against. My own backhand had serious structural limits, so I began noticing players in my age

group whose backhands had nice easy rhythm, and I asked who had taught it to them. To a man (and woman; one of them was Pat Canning, later Todd) they'd all learned the backhand from George Hudson, pro at the Berkeley Tennis Club.

I decided George was the coach for me, and then I found out what he charged for lessons—five dollars an hour. A lot of money in those days. He wouldn't go for the ballboy barter I'd used with Howard Kinsey, so I went to my parents for help.

"I have a weakness in my game," I told them. "I'm going to need some money to take some backhand lessons that I think will help me get over the stumbling block that's keeping me from getting ahead."

And Mother found the money—six lessons for thirty dollars. I found George to be good-natured, very talkative, a bit irrepressible. He wanted to make over my whole game, but I insisted "No, George, only the backhand." I had to keep reminding him not to tinker with my serve, forehand, or volley—"Just the backhand, George."

We got the stroke down by the end of that summer of 1937. I was sixteen. I won the state junior championships and also the Pacific Coast Championships, for boys eighteen and under. Thanks to those backhand lessons, I was on my way, and started traveling away from San Francisco for competition.

There was a Pacific Northwest circuit then, marvelous summertime venues at posh clubs in Portland, Seattle, Tacoma, Victoria, and Vancouver. Posh clubs, yes, but far from posh accommodations. My first year in Vancouver, three of us boys rented one room with one bed. We tossed a coin for who would get the springs, (me), who the mattress, with the third man out sleeping on the floor.

The Northwest was my first testing of non-hard courts. Portland and Tacoma had clay, and Seattle's surface was asphalt like at home, but the Canadian ones were on grass. My first match on grass was nearly a disaster. Running for a ball, I slipped and slid into the net post, wrapping myself around it. No big deal. I was young and pliable.

Junior tournaments were held simultaneously with regular men's and women's play. Young players from Southern California would be there in force, such as Bob Falkenburg, later to become a lifelong friend, and Gertrude Moran, who would reinvent herself in years to come as "Gorgeous Gussie" of lace panty fame.

At the Vancouver Lawn Tennis Club in 1939, I had my first exposure to Australian Davis Cuppers John Bromwich and Harry Hopman. How smooth they were with their killer instincts!

From that time on, whatever my age, I always wanted the best practice I could get. The camaraderie of tennis I also liked very much. Kind of made up for my lack of real brothers and sisters.

# 3. Urge to Compete

I WAS NEVER MUCH for girls when I was growing up. Not until Margaret Osborne (later duPont) came into my life.

She and her mother were San Franciscans who would come out to Golden Gate Park to watch us juniors play. By my fifteenth year, I had become a player of some regard and was good practice for any woman who might come along the pike. Margaret was four years older than I, and already winning national championships, so when she invited me to be her partner for a handicap tournament at the Cal Club, I eagerly accepted.

It was a turkey tournament, and they handicapped the hell out of us. We were love–40 at the start of every game, meaning we had to win three points in each game before we could even begin scoring. We had to work our tails off before we could get to 15–all. Well, we won, and was my mother surprised when I came home carrying a huge turkey, for she knew I hated the stuff. She and dad ate well that Thanksgiving, though.

In those days, after school and on weekends, I practically lived at Golden Gate Park and in the pool hall at its Stanyan Street entrance. If I had a match at nine in the morning, and another in the afternoon, rather than go home and come back I'd just hang around and shoot pool. I was good at it. If someone came in and had no one to play with, the pool hall would fix him up with the "house man," who was, on occasion, me. Double or nothing if he wanted. I earned more money for the pool hall than I lost. Enough to keep me in tennis rackets until a later year, when I started getting them for nothing.

Fred Earl, a well-known coach from Modesto Junior College, dropped by the park one day. He watched me play awhile and commented, "Gosh, you boys are hitting the ball awful hard for it to stay in."

"Don't worry, coach," I assured him. "Someday, all those balls *will* go in."

Some thirty years later, I visited Fred in a hospital. He was in his seventies by then, waiting to have a shoulder replaced, and was looking forward to getting it repaired so he could start competing in his eighties. He reminded me of our conversation so long ago. I was deeply inspired by him.

At seventeen, going on eighteen, I could give a lot of the players in the men's division a good tussle. I remember going to my first National Clay Courts in River Forest, Illinois. I took the train (thanks to Dad's pass) from San Francisco/Oakland to Chicago. The night before we were to get in I picked up a Chicago paper, turned to the sports section, and found to my dismay that I was to play the opening match with none other than the reigning number-one U.S. player, Bobby Riggs.

My survival in the tournament was not a likely thing, so when I arrived I hoped to find someone—anyone!—to at least hit with. The Wilson people had arranged accommodations for me, and a beat-up car which I used to drive to River Forest. The car had a tendency to slip out of gear. I also wasn't too sure of the way. I followed some railway tracks but found, to my horror, that they led down into a tunnel where the paving ran out. I backed out before a streetcar came in, and, quite shaken, continued on.

Finally arriving at the club, I inquired around for someone to play, and lo and behold Alice Marble invited me to play a set. And I won it! I realized, of course, that it was just practice for her—that she wasn't fully extending herself. But in my mind, I had played her for her own title—Women's Champion of the United States. She was a couple of years older than me, very tolerant and good-natured.

My match with Bobby was, as expected, lost. But he was the first (and only, ever) person to say anything nice about my unique

"inside-out" forehand. "Now, that's a good shot!" he shouted across the net as we played our match. Coming from such a personage as him, those words were music to my ears.

Part of the players' tactics of the time was leaning on the linesmen. I was well aware of this at seventeen and knew that Bobby was a master at it. At another tournament that summer, having lost in the first or second round, I served as a linesman at a Bobby Riggs match.

I do believe that kids my age who are experienced with tennis make the best linesmen of all because they understand the game and can watch the flight of the ball before it lands. And, being young, kids have very good eyesight. They focus on the spot where the ball is about to land, at just the right moment.

I was calling the "long line" and Riggs hit one down it. "Out!" I shouted. Riggs looked hard at me, obviously thinking it was in. At the change of courts, he came over and said "Tom!" (I didn't know he remembered my name.) "How could you call that ball out?" He said it as if I'd made the worst mistake in the world. But being from Golden Gate Park, I wasn't afraid of him and cooly replied "But Bobby, it *was* out!" And he let it go at that.

I don't like losing. Never have. (Not even now, in my eighties.) Every time I lose I believe I should have played better. But win or lose, I would like to think I was always known as a good competitor. I might growl because I lost, but underneath the waters ran smoothly.

Early on, I discovered that temper for a tennis player is a good thing. You *should* have a temper. You should be emotionally into your sport, or you won't do your best. When your temper is working, your adrenaline pumps and you have more energy and determination, and become a better competitor.

When I was young, the madder I got, the harder I worked and the more I concentrated. Everything else would be shoved out of my mind except the score, the ball, and what my opponent was likely to do. Temper is a very good tool to have working for you—but there are players who let their tempers get hot and they just come apart at the seams. It's all right to lose your temper, but don't lose your control!

My learning how to behave when invited to play in this tourna-

ment or that was largely thanks to Perry T. Jones taking me under his wing. Every young person seriously interested in tennis should be so fortunate as to have a Perry T. in his or her life. In the 1930s and '40s, he was an able, enthusiastic, and gifted promoter of tennis for Southern California, and for the whole United States for that matter. It was he who discovered and groomed Jack Kramer, and sensing the greatness that was to become Jack made sure that he had the best player in the world to practice with regularly—the incomparable Bill Tilden.

Perry T. had an office at the Los Angeles Tennis Club. He wanted to sell tennis to the financial community, the movie community, the wealthy and sports communities, and to that end he organized everything. He was always on the lookout for young players who could behave decently and look good so that his rich friends and Hollywood actors and starlets would want to come and watch tournaments. And thereby raise attendance.

When I started playing the "Southland," as San Franciscans call it, Perry T. was right there at courtside. If you were willing to go along with him, he would point out the advantages to each young man. "We will see that you get a chance to play in any of the tournaments you want to," he said. "If you have any problems with linesmen on the court, or anything at all, you just come and tell me and we'll get things fixed.

"And if there are any affairs in the evening, we want you to go and be appropriately dressed in coat and tie, and we'll take care of that, too. We will pay for everything, but we expect you to wear what we buy for you because we know you will look good in the clothes we select."

To this day, I say "Please" and "Thank You" to the simplest of requests.

Best of all was Mr. Jones making "his boys" feel like true VIPs. He would walk us, one at a time, never in a group, to each of the six gates at the Los Angeles Tennis Club. He'd say to the gatekeeper, "Now, Joe (he always knew their first names), this is Tom Brown, one of our esteemed players. He is seeded number three in this tournament,

and we want to show him every courtesy. Have a good look at him, because he will not be wearing an I.D. badge." (Badges were too uncouth, Mr. Jones felt.) "I want you to remember his face, so you will admit him without question anytime he comes to your gate."

"Yes, sir," they always said to Mr. Jones, and they meant it.

Perry T. was always hopeful that his players would choose to remain in Southern California, fall under his tutelage, and go to college there. Well, I didn't want to do that—San Francisco gets in your blood, and I wanted to remain close to my parents—but he liked me anyway, and we always had a strong relationship.

I don't know if he was a bachelor or widower, or what. He was very private about his life outside the tennis club. He lived in a nice house in a nice part of Los Angeles, and I was his house guest on several occasions.

"You'll have your own room," he assured me, "and we have an extra car for your use. We want you to feel at home, and feel free to come and go. However, I do like such-and-such gas station particularly, and I want you to take the car in to be serviced before you leave, and washed, and the floor part cleaned, and of course there will be no charge to you."

Well, naturally, I came away with respect and admiration for a man who ran things smoothly like that.

In Northern California, tennis had another genial, outgoing mover and shaper in James B. (Jim) Moffet. If there were players in Northern California (like me) that Perry T. wanted, Jim would see that he got them. And vice-versa. He and Perry T. were instrumental in getting the balance of control of tennis in the U.S. more evenly distributed away from the East and more to the Midwest and West. How they did this was to canvass the western tennis clubs so that more would join the U.S.T.A. and outnumber the Eastern clubs.

That was the beginning of the shift of tennis power from the East Coast to the West.

## 4. On the Road

THEY CALLED US "HACKERS." Ambitious young men of college age determined to reach the very heights of tennis, the National Singles at Forest Hills, New York.

To get there, you had to have a national ranking earned by competing on what was called the "Eastern Circuit." Seabright, New Jersey; South Orange, New Jersey; the Hamptons, Long Island; Newport, Rhode Island; Chestnut Hill, Massachusetts; and a host of other stops, all played on grass courts. Only the top seeds received living expenses. The rest of us paid our own way, cutting corners however we could.

I was a University of California student when I first played the Eastern circuit in 1940. I was eighteen and one of several hackers who latched onto Vic Seixas. He, too, was lean on money but had a fine Pontiac convertible that could seat four. Eddie Moylan, Sam Match, Vic, and I were all about the same age. We would finish a tournament, hop in Vic's car and drive on to the next stop, taking turns at the wheel and splitting car expenses.

Vic, who was from Philadelphia, knew his way around, having played Eastern tournaments since he was a junior. He was very good humored and friendly. We would shoot the breeze about what we hoped to accomplish in tennis—and then we'd arrive and reality would set in. We'd find ourselves at the mercy of the tournament committee.

I've been asked if my social life in my long-ago college days was pretty much limited to tennis. Tournaments would usually last a week,

so, sure, you'd meet girls. Daughters of the members of the club, usually. There was always a coterie of pretty young women around.

But there wasn't much we could do about it. We were pretty doggone busy with our matches, and also pretty goddamn broke.

The usual deal for hackers was one free meal a day in the clubhouse dining room, a privilege that was canceled as soon as you lost. To be sure of eating on the house, most of us would enter all three events—singles, doubles, and mixed doubles. (I quickly became a doubles specialist.) After our final elimination, we hackers would skip the shower and head straight for the dining room before our name could be scratched from the "free lunch" list.

As to hospitality, it would range from bleak (a row of cots set up in a damp, smelly boathouse lively with hungry mosquitos in Seabright, New Jersey); to spartan (cots again, laid out on a cold, drafty squash court in Southampton, Long Island); to sumptuous, epitomized by Newport, Rhode Island, where we were often billeted in grand mansions on private estates and provided chauffeurs and breakfasts cooked to order.

Ah, those were the days, my friend!

It was an innocent time for Americans, just before our entry into World War II. For two years, San Francisco hosted the Golden Gate International Exposition on Treasure Island in the middle of San Francisco Bay. Nick Carter and I, tennis buddies from Golden Gate Park, got part-time jobs there for about a dollar an hour, pushing tourists around in rickshaw-like contraptions. We'd wrap them in blankets good and snug and jog them around to the principal sights.

My favorite stop was the Spanish pavilion. Beautiful girls. Lovely music. Exciting dancing—flamenco and bolero. The fair piqued what was to become a lifelong interest in things Spanish for me. Although I majored in political science at college, my minor was Spanish. Later, when I started traveling extensively for tennis, I always asked to room with a Latino player so that I could practice my Spanish. I learned every swear word they used on the courts, and there were some dillies.

I played number one on the tennis team all four years I was at U.C. (A touch of serendipity here. My aunts Ara and Lillian, my father's sisters, played doubles for the U.C team 100 years ago! Perhaps it was in the genes that tennis and I should get along so well.) Our principal rival was Stanford University. Before a match, people would say to me, "You guys should roll right over Stanford." I'd tell them, "No, sir, you're mistaken. Their number one player is currently the U.S. National Men's Champion." That was Ted Schroeder, pretty much invincible in those days, although I managed to beat him one out of the two times we played. After the war, Ted teamed with his longtime friend, Jack Kramer, to win many national doubles titles.

Ted loved to play bridge, which we did on rainy days. Playing cards was second nature to me, learned in the Golden Gate Park days as an interesting way of killing time until the next match. I became very adept at cards. So was Ted, but he had a hell of a temper when bridge games didn't go his way. More than once, if he didn't like a hand, he would snatch up the cards and throw them out the window. He also tested my mettle at the dining room table when we were Davis Cup teammates. But that's a later story.

It was at the Intercollegiate Championships at Northwestern University, Chicago in 1945 that I met Pancho Segura. He was no more a college student than I could fly, but he was the number one player for the University of Miami. Gardnar Mulloy, at that time the coach for Miami's tennis team, discovered Pancho at a tournament in Ecuador and hastily signed him up for his squad.

Pancho was quite a character. A cute fellow. Couldn't speak much English, but was very humorous; and he knew, even then, how to act up to make everybody happy. Because of having had rickets as a child, he walked pigeon-toed, but boy, could he run!

I reached the finals of the singles in that championship, losing to Pancho in three straight sets. He beat me—handily, too, I must admit. I wasn't strong on clay yet, and he was already the third-ranked player in the United States. Twice more in my lifetime I was to play

against Pancho. At Wimbledon in my year of glory (1946), I lost the first set to him but won the next three. And much later in the Grand Masters, when we were both over the hill and didn't play competitively all that much, we played, but I don't remember who won.

Pancho became a national hero to Ecuador. He put his country on the map for sport and tennis. A postage stamp was named after him. He played all over the world, and the crowd just loved him. He never lost (on purpose, I think) his Ecuadorian-Spanish accent, and he always walked pigeon-toed and knock-kneed. And yet he managed to be one of the fastest moving players on the tennis court.

And then there was Gardnar Mulloy. He must have been on the sidelines when Pancho and I played that Intercollegiate final. But Gardnar and I didn't officially meet until 1942, when I was 19 and playing in my first Nationals. Gardnar always seemed like an old man to me. For as long as I can remember, he's been active in tennis. He's nine years older than I.

That year, 1942, Gardnar and I met in the round of sixteen at Forest Hills. We had quite a tussle. I lost, but it went to five sets and that encounter was good for me. Having just come on the scene, the near-win gave me my first national ranking, number sixteen. He was then number five or six. He told me later that before the match he thought I was just another young punk out of the West—one of those Californians who was more flash than substance. But in that five-set match, I earned his respect.

Even then, Gardnar seemed quite set in his ways. He was very cantankerous, but was always fair on the tennis court. He treated his opponents fairly, but not always kindly.

I think it was an inherited trait. During my law school years, 1946–1949, I was playing the off-season (wintertime) Caribbean tour that began and ended in Miami, Gardnar's hometown. I reached the finals of the tournament there, against Gardnar. We played a hard-fought match that he won in four or five sets. After the match, there was a ceremony for the presentation of trophies and he, being the local hero, was showered with accolades.

The typical comment of the day to the loser (me) was, "You played very well, but our guy was just too good for you." It was a very hot day and I didn't feel like sticking around but of course I had to. This old guy came up to me and started expressing his opinions on how the match had gone. That was the last thing I wanted to hear. I had no desire to engage in conversation with this nincompoop who seemed fascinated with the sound of his own voice.

I moved away from him but he sidled up to me again, wanting to engage me in conversation. Well, one of the things you don't do as a spectator is insist on conversing with somebody who's just lost a hard match. Particularly if the player is not being paid for his efforts. If he's a pro, well, that's a little different. The public owns a piece of you because you're being rewarded by a share of the gate receipts and so forth. And you owe it to them to be gracious and somewhat conversational.

Mulloy came over then, in the midst of the old guy trying to ask me questions. I figured Mulloy knew everybody there, so I entreated him, "Will you please get this old son-of-a-bitch off the court?" "Yes," he said, and walked over and said something to the old guy, and he left.

Weeks later, when Gardnar and I were playing again in another tournament, he said to me, "Do you remember that old guy who was pestering you at Miami?"

"I sure do," I said.

"Well, that old son-of-a-bitch was my father," said Mulloy. "And you were right. He should have known better. He had no business being there."

Many years later, 2002 to be exact, I was tapped to be on the Gardnar Mulloy Cup team in Europe, a Davis Cup–like competition among the best eighty-year-old players in the world. Gardnar, well past 90 then and running out of people his own age to play with, was the captain. Age exacts a fearful toll. We played together in doubles, and were awful.

# *Second Set*

# 5. In the Army Now

IN MY SENIOR YEAR at Cal, at the age of twenty, I enlisted in the Army for service in World War II. I would have preferred to join the Air Force, but the examining optometrist said my depth perception was lousy, and that I could never land a plane, let alone, and I'm quoting him, "play an eye coordination sport like tennis."

I didn't enlighten him that at that very time, in 1943, I was the reigning tennis champ of Northern California.

The Army assigned me to complete my college degree and even get in a first semester at the University of California's Boalt Hall law school before calling me to active duty.

I packed my tennis racket, in case—one never knows—there might be a chance to use it. And, sure enough, on weekend leaves from basic training at Fort Benning, Georgia and Camp Campbell, Kentucky, there *were* opportunities. As Pfc. Brown, I won the state tennis titles of Kentucky and Alabama.

Among my former tennis buddies, Vic Seixas was in the Air Force, piloting replacement planes across the Atlantic; Gardnar Mulloy was in the Navy doing heroic stuff as an L.S.T. commander; Jack Kramer was in the Coast Guard; and Bobby Riggs was conning his fellow sailors in various betting games while stationed mostly in Hawaii.

Among players I was to come up against after the war's end, a number were on the other side, fighting for their own countries, Germany or Japan. Some endured years in prisoner of war camps.

The Brits lost many players in the flower of their youth, as did all

the countries in continental Europe. For nearly a decade following the war, prewar champions like Fred Perry had no chance to touch a racket and never fully regained their potential. The great citadel of Wimbledon, itself, took sixteen hits from bombs. Amazingly, the tennis courts were never closed for the members. In 1944 the Armed Forces played there too. Wimbledon's parking lots were converted to farmland, including a piggery. And the grounds were used for military drilling.

I truly believe in tennis as a way to world peace. In head-to-head confrontations, you can have games with allies and former enemies and nothing matters but the match of the moment. That was my thinking when I took along my racket for the invasion of Southern Germany. After all, there might be a chance to play somewhere along the line, as there had been in basic training. I also stashed in my duffel a French grammar book. (Never got to use the racket, but the phrase book sure came in handy.)

I was trained to be a mortar gunner, and on February 6, 1945, I shipped out from Boston, Massachusetts with the 20th Armored Infantry Division of General George Patton's Third Army. The ship that took us across the stormy Atlantic that winter was a small converted freighter. It had several levels and the interior of the ship contained vertical rows of hammocks with not much room in between. If you wanted to turn over in your hammock, you had to ask permission of the guy above as well as from the guy below you.

The division's band played "Sweet and Lovely" for us as we descended toward the bottom of the ship, but somehow this cheerful and sentimental love song did not calm our nerves.

The Atlantic was rough, and the small freighter rolled both side to side and up and down. Naturally, everyone got seasick. The ship's doctor got on the loudspeaker. "Men," he bawled, "you must eat, no matter how bad you feel." I'd been deliberating whether or not to attempt the orange I'd taken from breakfast. My stomach told me no. But the doc should know better, right?

Wrong.

Somewhere in the middle of the crossing, the ship shook violently from what we feared was an explosion from a torpedo. "Now's the time to pray to Gawd, men," I remember a southern boy yelling. It wasn't a torpedo, we gratefully learned, but depth charges laid down by our protective convoy to scare away German submarines.

I was a fortunate soldier. The war in Europe was already beginning to wane as we tramped through Southern Germany, Austria, and France.

In France I was assigned to one of the half-tracks, personnel carriers that covered the flanks of the tanks. Nosing beneath the floor boards, where we kept ammunition, spare guns, and such, I found enough space for my tennis racket. There it sat throughout my stint in the war, protected and ready for action.

Only once was I personally involved in a battle. My unit rolled into a small town near Munich and made haste to occupy it. I was riding on the back of a tank when all hell broke loose—Germans were opening fire with their 88s. We jumped off and took refuge in the just-captured town, leaving it to the tanks to duke it out. Some of our boys were hit by shrapnel.

Looking back on it, it seems as if the Germans were less upset by our invasion of their town than by our taking away their local supply of beer. The town had an active brewery.

One day, patrolling alone with unaccustomed rifle over my shoulder, I came upon two very young and scared German soldiers and herded them back to camp.

"Aw, turn 'em loose. We got too many," said my sergeant. I have often wondered if one of those boys was the future Pope. I've since read that as a boy forced into the "Hitler Youth" movement late in the war, Pope Benedict was captured and released by friendly Americans.

In the French countryside, a buddy and I used to forage about, trading candy and cigarettes for hard apple cider. I learned a good bit of conversational French that way. We enjoyed watching schoolchildren trudge to school in the mornings, solemn-faced and quiet,

canteens filled with hard cider hanging from their shoulders along with their schoolbooks. At the end of the school day, they would pass us again, their little faces by now rosy-pink, their step springy, their voices very animated—and their cider canteens obviously empty. *Vive la France!*

In war, there's a lot of hanging around waiting for things to happen. There were times for occasional poker games with my buddies. My winnings were enough to send home double my paycheck most months.

During my army days, the higher-ups were scared to death of venereal disease. "Boys will be boys," was their way of thinking. "We can't let them loose on leave without giving them a good supply of condoms."

So, when we signed our leave papers, we did not get our dismissal from the supervising sergeant until we verified that we had been given condoms. There was an ample supply of them. They may not have been of top quality, but none of us back then knew enough to know the difference.

There was no limit on the number of condoms we could take. So I built up a supply. I don't know why. I certainly was not very adventurous with women. I just thought they might come in handy some day.

And sure enough, they did. Sooner than I could have imagined.

While war in Europe was winding down, I went to check on my racket stashed away in the half-track. It looked okay, but then I looked closer. Two strings had popped. So though it had survived the war, it wasn't going to do me any good. With regret, I tossed it away.

In late summer of 1945, our unit was sent home, pending redeployment, we all expected, to the war in the Pacific. But the atomic bombing of Hiroshima accelerated the end of World War II.

While still in uniform, I was permitted to engage in various tournaments and was able to win back my titles in the San Francisco singles and the Pacific Coast singles and doubles, and regain my ranking as number one in Northern California.

I had one final assignment before discharge from the service in February, 1946. The army transferred me to JAG, and promoted me to Lieutenant, jg to organize a nationwide tennis tournament for the armed forces. It was held at my boyhood courts in Golden Gate Park.

No well-known players entered, but the atmosphere was very special. The Army Band from San Francisco's Presidio strutted their stuff playing Sousa marches before the matches began.

# 6. Year of Glory

FOLLOWING MY RELEASE from the army in February, 1946, I wasted no time in getting back to tennis. Law school could wait a few more months.

The La Jolla Invitational Championships near balmy San Diego were big in those days. They were held at the exclusive La Jolla Beach and Tennis Club, and hosted by its owner and avid tennis booster, William S. Kellogg. He would invite the top players of both Northern and Southern California, personally greet us at the airport, and see that we were put up in sumptuous accommodations.

We players loved that February event. It kicked off the tournament season grandly, especially that winter of '46, when it was rumored that the winner might be sent by the United States Tennis Association to the first postwar Wimbledon in June.

Bob Falkenburg was the favorite to win the singles, but, by golly, I did. A second win in a subsequent tournament, also over Bob, cinched it for me. Jack Kramer and I were tapped to go to Wimbledon. The world's top tennis tournament would also condition us, we were told, for possible consideration for that year's first postwar Davis Cup team.

Perry T. Jones took me aside. "Now, Tom," he said, "you'll be playing doubles at Wimbledon with Jack. He's had a lot of experience, so you listen to him."

Advice taken. I realized I was a second-fiddle choice. Jack was a shoo-in to go, and the other established players of the U.S.—Billy Talbert, Gardnar Mulloy, Frank Parker—were not available for

Wimbledon, being committed to play qualifying Davis Cup matches that spring and summer.

The U.S.T.A.'s appointed means of transportation was a ship from New York to England. I remember starting my trek on the back of a San Francisco streetcar in the middle of rush hour to catch a plane to New York for the sailing. Although I was excited, I didn't forget a thing.

My first packing priority was my rackets. I was carrying five or six of them, all strung with the highest grade gut. Gut was expensive in those days—maybe fourteen dollars per racket—but no way was I going to Wimbledon and play with inferior stuff. Synthetics of that time were terrible; no matter how tightly they were strung, they would never pull taut enough for a ball to rebound firmly.

I was worried that the wet sea air might get into my rackets. *Voilà!* I remembered all those condoms I'd been given in the army, and the good use I could put them to now. A friend helped me pull them over my racket heads, stretching them to their very limit. They fit tightly, and some of them broke, but I had a good supply so I could afford some breakage.

In my luggage were also eight little white hand towels to use on the Wimbledon courts. I'd been forewarned that everything you wore on court had to be white.

In New York, I learned that Jack had already left. He'd flown over, so he could have more time in England for practice. So be it; he had far more clout than I.

The rest of us did as we were told and sailed on the SS *Uruguay*. I was in the group along with Budge Patty (who was Wimbledon-bound on his own), and the women's U.S. Wightman Cup team comprised of Pauline Betz, Margaret Osborne, Louise Brough, Pat Canning Todd, Doris Hart, and Dodo Bundy.

Compared to my army transport experiences, the *Uruguay* was quite a nice ship. Although not fully converted from carrying troops, it had honest-to-God bunks, and separate staterooms. Men and women were segregated, though—there not being enough private

bathrooms. Didn't do much on the six-day crossing but walk the decks, read, sleep, and get to know Budge pretty well.

At last we arrived, took the boat train to London, and checked into the Rembrandt Hotel. The first thing I did was to strip those condoms off my rackets. They pulled off easily, and had done their job. The wooden frames and gut strings were just fine.

How did I feel when I first set foot inside the hallowed grounds of the All England Lawn Tennis Club, better known as Wimbledon? I suppose I had an "At last I'm here" inner excitement, but truly, as I was driven in that first day, it just seemed like an entrance to a large stadium. There was a big gate with an attendant on duty, and when we players arrived with the distinctive green and purple flag (the colors of Wimbledon) flying like a diplomat's banner from the hood of the car, the gate would swing open, with a couple of policemen standing by to make sure that none of the public swept in behind us.

There'd be two, three, or four of us in a car. The club dispatched chauffeur-driven cars all over London to wherever the players were staying. By calling the sacred phone number—Wimbledon double-two–double-four—we would request a pickup time, allowing ample time so that a car perhaps assigned to some other hotel could swing by ours and pick us up too.

We'd be let off about fifty feet inside the gate, up a slight hill, at the tournament office where we'd register. Just to the left was the men's locker room, which you needed a pass to enter. We would be given an I.D. card, a sheet of instructions with a list of social events for the tournament, and tickets for tea and lunch. And they gave you a badge that read "Player," which you wore around your neck on a string.

Kramer's name was well known; he had been, at seventeen, the youngest member of the last Davis Cup challenge in 1939, and he was currently considered America's best player. Now twenty-five years old, he was seeded number two for this Wimbledon meet. Number one was Australia's Dinny Pails.

I, at age twenty-two, was unseeded because there were not

enough data, due to my recent discharge from the army. My name meant nothing at the start of the tournament. I might as well have been "Mr. Anonymous." But I fooled 'em!

Never did I dream I would get as far as I did. I struggled a bit in the first round against a Brit, M.S. Deleford. But my cannonball serve carried me to a 6–4, 10–8, 6–2 win. I breezed through the second round versus another young Englishman, Ron Carter. It was a little disconcerting to notice his footwear. He wore socks *over* his shoes to prevent slipping on the wet grass.

On the eve of the third round, I was returning to my hotel on the subway from Wimbledon. By chance, my seatmate turned out to be an American tennis writer. The conversation naturally revolved around potential winners. The columnist appraised Pancho Segura's chances highly, and went on to describe how Dinny Pails would probably defeat Pancho, the number-four seed, in the finals. I was noncommittal. When we reached our stop in London, the writer remarked, casually, "By the way, who do *you* play tomorrow?"

"Segura," I replied, with a wink and a smile. The writer's jaw dropped.

The next day, the morning of my match with Segura, Pancho, Jack and I were bantering in the car Wimbledon had sent for us. "Now, Sneaky," Kramer said to Segura, "you're playing awfully well. But just for the hell of it, I'd like to throw a little money on Tom for a friendly bet. How about your giving three-to-one odds? That would be fair since you walloped him the last time you two played in the intercollegiates. What d'ya say?"

Segura agreed and said to me, "You can have my bet if you want it."

"I want it," I said.

So out we go, on Centre Court, because of Pancho's high seeding. It was, of course, my first experience there and the feeling was pretty damn awesome. Panicky even. You realize there's no escape. Not only that, but you have nothing to fiddle with to disguise your nervousness. Usually, you'd have your rackets to hold onto, but for Centre Court an attendant carries them so you have nothing.

You might as well be naked.

I lost the first set, but then began playing quite well and the match turned around. Pancho's backhand was good, but I could hit forehands that drew him to the far side of the court, and it became one of my better matches. I piled up a 5–love lead in one of the sets after that, won the match 4–6, 6–3, 6–3, 6–3, and duly collected my fifteen pounds.

It was the biggest upset of the tournament to that date, and the press had a field day. "Plain Tom Brown of the U.S.A. stole the show," said the *New York Herald Tribune*.

"Coast Kid Tops Segura at Wimbledon," the *New York Daily News* wrote.

"Segura's downfall came just at 4 p.m., the traditional 'tea hour' when Wimbledon fans flock to the lunch tables on the lawn, and it sent swarms of autograph seekers crowding around the hitherto virtually unknown Brown," reported the Associated Press.

Quoting another writer, "Everyone started asking questions at once. Who was this Tom Brown? What had he ever won? Where was he ranked in America? When someone said he wasn't ranked at all, a veteran English tennis observer shook his head and said, 'Not ranked at all, and he can play tennis like that? I take my hat off to the Americans.'"

Heady stuff, to be sure, but I was too experienced at how matches can go against you in tennis to be carried away by a feeling of euphoria.

I rewarded myself with a deep, hot soak in one of the bathtubs Wimbledon provides in the elite men's locker room, closest to Centre Court. It was a very civilized arrangement. Five or six huge tubs in individual glassed-in cubicles. You could soak there for hours, with no one pestering you to get out. To this day, tubs have been my favorite way of relaxing. I've never liked showers.

But back to the tennis.

My fourth match was against Tony Mottram, Britain's best player, and we were told that Queen Mary and Prime Minister Clement

Atlee would be watching from the royal box. I was summoned to the referee's office two hours ahead of time. They assigned a sort of palace guardian to me, as was protocol for any player set for Centre Court. Wimbledon takes no chances that you might not make it to the court on time. If you have to go to the can, he goes with you. Take a shower, and he's waiting outside the door. Stop at the tearoom for something to eat, he's by your side. And he keeps an intercom with him so they know where you are at all times.

It was an awfully hot day, but I thought I should show proper respect to Britain's Queen Mother by wearing long flannel pants instead of displaying my skinny legs in shorts. Too late, I noticed that my opponent, the Brit, was comfortably garbed in shorts.

Time to play, and Tony and I walked out together, preceded by a male escort. About fifteen steps onto the court, the leader stopped. We did, too, and at his signal turned around, faced the royal box, and bowed to the queen. I'm told my bow wasn't too good, but practice makes perfect, they say.

Although perspiring heavily in my long pants, I routed Tony in straight sets and found myself in the quarterfinals, the only American left in the running. Budge Patty had been put out by Dinny Pails. Jack Kramer was also out of the singles. His racket hand suffering from a bad case of blisters, Jack had lost to Jaroslav Drobny.

In the fifth round, I didn't have much trouble with Feranja Puncec of Yugoslavia, but then I got my comeuppance in the semifinals versus Yvon Petra. The two-meter man, they called him. He was over six-seven, thirty years old, the current number-one player of France, and a prewar star of the French Davis Cup team. He had spent two years as a prisoner of war of the Germans, and he was one tough hombre. Yvon was seeded number five in the tournament.

I was ahead two sets but let my guard down and he swept back and took the next two. He was leading in the fifth set, 5–2. (Shades of the Bromwich-Falkenburg match, where this book began!) I managed to bring the decisive set up so we were even. At one point,

I was within one game of victory, but in a cliffhanger—8–6, as I recall—Yvon won the match and went on to take the championship.

"Brown Beaten By French Ace in Hard Scrap," the A.P. wrote. It sure was.

Meanwhile, my doubles play was going well. Very well. Doubles, historically, doesn't get nearly the publicity that singles does. But Kramer and I, the number-two seeds, won the men's doubles against Australians Dinny Pails and Geoff Brown, who'd been seeded first.

Jack had just twelve words for me before we began our match. "Okay, kid. Just get your first serve in, and get in quick." Our slashing net game bamboozled them—6–4, 6–4, 6–2.

With Louise Brough, I captured the mixed doubles from Geoff Brown and Dodo Bundy. Ironic, although I didn't realize it at the time, that Dodo was the daughter of my father's boyhood tennis pal, Tom Bundy.

Louise had just completed a tough three-set women's finals before being called out for the mixed. "Are you ready, Miss Brough?" I heard them summon her. "Just wait till I put my shorts on!" she hollered back.

Louise was a joy to play with. We were just a year apart in age. We had met when we were fifteen and sixteen, playing the northwest circuit. But we'd never played together before that Wimbledon tournament. We found we didn't have to ask each other to do certain things. We never had an argument or disagreement. She would say something, or I would, and it would be answered by a nod. None of this "Yours!", "Mine!", "I've got it!" kind of crap.

She knew the "twilight zone"—balls that she might be able to put away but which her male partner, having a greater margin of speed and strength, would have a better percentage of doing. I always knew by her body language whether she was going to step in and take it or stand aside. We orchestrated together very smoothly.

Two more nice memories of that glory year at Wimbledon. The American Ambassador, Averill Harriman, held a party in honor of the American players. "How do you find the food here?" he asked me.

"Well, sir, I surely miss having fresh eggs in the morning," I answered. (Food shortages still existed in those postwar times.)

Next morning at the hotel, the clerk at the reception desk hailed me. "Oh, Mr. Brown, we have something for you." It was a little Easter-like basket with a card from the ambassador that read, "Hope you enjoy your breakfast." The basket contained one beautiful big brown egg.

At the same party, I chatted with an attractive girl of about my age. She turned out to be Prime Minister Atlee's daughter. She told me about her stint in the war as an ambulance driver, and I told her about my ambitions to become a lawyer. She asked me what I'd seen of London. I told her I hadn't had a chance to do any sightseeing yet.

"How would you like a personal tour of London?" she asked me.

"Gee, that would be great," I replied, and the next morning (yes, the same morning I'd received the ambassador's egg) she picked me up at the Rembrandt at the wheel of her own car.

"I thought, since you were going to law school, that you would like to see our House of Lords," she smiled. And that was our first stop. There was this giant guard at the door wearing the traditional tall bearskin hat, looking very fierce. She nodded to him; didn't have to say a word. He nodded back, bowed, and swung the door open for us.

Quite a thrill for this San Francisco boy, because the House of Lords is not open to the general public. I wrote home and told my parents about it. They were amazed that such a royal event could have happened to me.

# 7. Glory Be! More

POST-WIMBLEDON, 1946, was no letdown.

Budge Patty, Margaret Osborne, Pauline Betz, and I flew to Varberg, Sweden to play a command performance for King Gustav V. We did a Davis Cup/Wightman Cup format for him versus Sweden's best players. It was fun, and a great treat, after five weeks of bland spartan food in England, to stoke up on fresh fruits and veggies.

I considered Budge to be considerably more worldly than I. An incident in the locker room while preparing to take the court changed my mind. We were both at the window, watching Lennart Bergelin's match down below. (Lennart was later to become Bjorn Borg's coach.) We were standing nude in the hot summer heat.

Suddenly, the door flung open and two cleaning ladies, bold as brass, swooped in beside us to also have a look. At the tennis, not us, I hasten to add. Budge hastily pulled a towel around him. I didn't bother.

The King, then eighty-eight, was very gracious. I asked his aide if the King still played. "Oh yes, doubles," I was told. "And how is his eyesight?" I wondered. The answer was quite diplomatic. "We don't question his calls." Fair enough, I thought.

Tennis, Swedish royal-style, was delightful. They had an orchestra playing Strauss waltzes, and they served large portions of vanilla ice cream with strawberries.

On to Brussels then, for another kind of elegance. We were guests, along with some other non-English speaking house guests, in the stately home of Belgian Davis Cupper Philippe Washer. Break-

fast was a grand occasion. There were two staircases from the bedroom floors of the house that led directly to the dining room, which was set up with a long, oval banquet table.

People would filter in from upstairs and waiters would hover about, bringing us whatever we liked. Bacon and eggs, crêpe suzettes—nothing was out of bounds. A young man like me from the public courts of San Francisco was never trained on how to handle such luxury, but you can observe and copy, and pretty soon you can fake it. One thing I noticed that has stayed with me since—a middle-aged lady (maybe thirty-five, which seemed pretty old to me at the time) paused at the midpoint of the staircase before descending, assessing the situation. She was alone. She started at one end of the table, extending her hand in greeting to the first person, on to the next, etcetera, muttering a pleasantry to everyone, and finally plopped herself down at an empty place. I thought that was a very civilized mode of behavior. Next morning I did the same with a *"Bonjour, je m'appelle* Tom Brown," all the way around the table. Felt very continental.

As for our host, Philippe, he would simply case the joint before taking a seat, and wherever there was a pretty girl, that's where he would alight.

Next, it was on to Paris for the French Championships. (In those days, that major event came *after* Wimbledon.) Almost as much an education as playing in the tournament was rooming with fellow Californian Budge Patty. He took to French living naturally, and was soon fluent in the language.

Budge was seeing two pretty young Parisians at the same time— Yvonne and Suzette. No sooner would he come "home" to our hotel room after a late date with Yvonne, than he'd saunter out again to meet Suzette. "How can you do that and still play a match tomorrow?" I asked him. "She's sending a taxi for me. What can I do?" shrugged Budge.

And sure enough, *l'amour* didn't seem to affect his tennis much. He and I paired together, and though we didn't win the men's

doubles title, we did capture the quarterfinals from the sentimental favorites, Jean Borotra and Jacques Brugnon, who'd been the French champions and two of the "Four Musketeers" of prewar fame, way back when Budge and I were still in rompers.

Partnered with Pauline Betz, Budge took the mixed doubles.

I, meanwhile, started off gangbusters in the singles but finally succumbed in the semifinals in a tight, tense five-setter against the tireless Czech, Jaroslav Drobny. The court surface I found very different from Wimbledon; clay plays a lot slower. Drobny ran me hard. He had a good touch, was very strong, and possessed a super drop shot which he kept feeding to me.

The crowds at Roland Garros were fairly enthusiastic, but it wasn't nearly as exciting as playing at Wimbledon. For my last breakfast at my Paris hotel, I asked the waiter wistfully for a glass of milk, as I had been doing unsuccessfully all the days of our stay. "Alas," he shrugged. "We have no milk. The Germans shot our cows." I didn't mean to sound blasé, but my answer just slipped out, I was that thirsty. "Well, then, please bring me champagne." And he did!

Thanks to some finagling, I was able to convert my return steamship ticket to New York to a seat on Air France. I was eager to get in a couple of tournaments on grass before the all-important National Singles at Forest Hills.

Billy Talbert, a fine player with a kind heart and the manners of an earl, met me at LaGuardia airport and drove me to the next tournament in South Orange, New Jersey. We were roommates there. He had an excellent sense of humor and was a most thoughtful and considerate guy. I remember his saying as we were retiring that first night, "If you'll excuse me for a moment, I have a little something I have to do." He pulled out a little black bag and syringe and said, as he injected himself with insulin, "This, I estimate, is shot number seventeen thousand, four hundred and eighty-six."

(Over the years, Billy won the national doubles with Mulloy seven or eight times and the national mixed doubles with Margaret Osborne at least as often. And he made the finals of the U.S. Singles

more than once. I think he was pushing the envelope pretty hard to play as much as he did, but there's no denying he was the leading figure in that day for proving you could engage seriously in sports while suffering from diabetes.)

My singles play at South Orange was mediocre; I was put out by the top player from the Philippines, Felicissimo Ampon. "Toast of Wimbledon Burned to A Crisp By Tiny Filipino," a sports page headline taunted.

The doubles, however, was good. The tournament committee needed a partner for the rising young star, Tony Trabert. He was only about sixteen, but was winning everything in sight. My exploits at Wimbledon had preceded me, so Tony was amenable to teaming with this old guy.

We hadn't met before. (A few years later, our lives were to intertwine in a personal, fateful way.) Tony was much younger but I liked his style. He was orthodox in that he believed in going in to the net regularly, which gave him a superior position over the other players. His technique was to move his opponents around, keep the ball deep, and when he got a short ball, close in on it. He was also an excellent volleyer. We saw eye-to-eye on how doubles should be played.

We were matched in the finals against the reigning doubles champions, Talbert and Mulloy, and we took the first set. They captured the next two, and it was nip and tuck to the end. They pulled it out.

I lost at Newport, also, but had a darn good contest in the semifinals against my old rival, Mulloy. I had energy to burn in those days but couldn't keep it up after Gardnar took the first set 15–13. His conservation of energies won the next two 6–3, 6–2.

I didn't do well at all at the National Doubles in Chestnut Hill (near Boston), Massachusetts. Budge Patty and I were upset in the second round. Moving on to Forest Hills, I felt recharged. Anything could happen, and it damn near did.

As a writer for the United Press poetically put it in an early round,

"The tennis gods sobbed softly today at the final wake of the old guard and the last pathetic attempts of the smallest of them all to recapture glory gone forever." What had happened? I had defeated the legendary prewar champ, Bryan M. Grant, Jr., better known as "Bitsy" for his five-foot–three-inch stature. He was thirty-six then, hadn't played a tournament for ages. (Years later, when I was 75, I was tapped to play on the International Veterans' Cup team named for him.)

I coasted along until the quarterfinals of the National Singles, when I astounded everybody by putting out Frankie Parker, the defending champion, in a nearly three-hour-long, five-set match. It was a bittersweet win. Frank, seven years older than I, had been one of my early heroes, an inspiring key to my own development. As a boy, he won the national championships for boys under fifteen, and also under eighteen, and just a couple of years later won the national men's championship. He was always very amiable and good-natured. Even on that day when he lost his title.

In Frank's defense, he had extremely poor eyesight. His trademark dark glasses were no affectation. As the late afternoon light grew darker, he found it harder to see the ball. And I must confess, I had blazing speed that day.

The gallery was "thunderstruck," to quote the great *New York Times* tennis writer, Allison Danzig, who went on to write, after my semifinal, straight sets, one-hour win the next day against my old adversary, Gardnar Mulloy, "It's the killer in the sport who brings out the crowds."

Killer? *Me?*

Well, I was to get my comeuppance facing Jack Kramer in the finals. It was a losing struggle. I won a service break or two, but, as Danzig wrote later, I had "shot my bolt of lightning."

A big black headline on the front page of the next day's *San Francisco Examiner* was like announcing the death of a statesman. "Tom Brown Loses To Kramer," it intoned. Indeed, I had lost—9–7, 6–3, 6–0, in just one hour and eleven minutes.

But taking second place in the nationals had a consoling aspect. It practically assured me of the last player slot on the Davis Cup Challenge team bound for Australia in just three months.

By the way, that singles final between Jack and me at Forest Hills was immortalized by Hollywood. Did you ever see the old Alfred Hitchcock thriller, *Strangers on a Train*? It's about a tennis pro tempted to become a hired murderer. I was the pro! Well, for a tournament scene in the movie, anyway. Hollywood needed a double for Farley Granger, the actor playing the tennis pro, and chose to do it authentically, using newsreel footage of our Kramer-Brown 1946 finals match. Because I had dark hair, as did Farley, whereas Kramer was blond, it was me the movie zeroed in on. You only see me from the back, and from a distance, but it's me all right.

Take it out sometime from a video rental store, and see!

I came home to San Francisco the most relaxing (and cheapest) way I knew, coast to coast by train. I didn't even unpack before going out early the first morning home for a game at Golden Gate Park.

I found in my accumulated mail an invitation, air fare included, to play in the Pan-American Tennis Championships in Mexico City. I did that in mid-October. Got to the finals. Was put out by Mexico's singles champ, Armando Vega.

Returning to San Francisco from Mexico, I found another welcome piece of mail. I'd been officially selected as the alternate for the Davis Cup team.

# 8. Highs and Lows

MIDDLE OF NOVEMBER, 1946. It was a long, long way to Australia. Four days flying, as I recall, starting from San Francisco with overnights along the way at Honolulu, Canton Island, Fiji, and Auckland, New Zealand. Last lap was by flying boat, a beautiful way to splash down in Sydney Harbour.

We were met by a battery of cameras. We were the first Americans since 1909 to come to Australia to challenge for the Davis Cup. A historic event, the Aussie press wrote, and they were hyping an easy win by their countrymen. The Cup had been in Melbourne since 1939.

Ha! We would see about taking it away.

We members of the Davis Cup team—Billy Talbert, Gardnar Mulloy, Jack Kramer, Ted Schroeder, Frank Parker (and wife Audrey), Captain Walter Pate, and I—were assigned separate rooms at the hotel, and I did a really dumb thing.

It was very hot—Australia's long summer was in full swing. In those days there was no air conditioning. Weary to the bone, I stripped, flung open the windows to catch whatever cool breeze might be stirring, unpacked, and threw myself, naked, into bed.

Next morning, I awoke with a cold but didn't dwell on it as I joined my teammates for practice. We flew on to Melbourne where the Cup matches were to be held, following more practice, exhibitions, and the national championships.

I played a tournament with Parker against two promising juniors. The kids weren't very good then, but improved rapidly in a year or

two. You know their names—Lew Hoad and Ken Rosewall. We beat them 6–3, 6–4.

By the end of our first week down under I was quite ill—I had caught the flu—which Pate used as an excuse to ban any more signings of autographs after play to our fans, mostly pretty young girls in bobby sox.

Pate believed that delay in getting to the locker room to cool down after playing in Australia's hot sun was what had weakened my immune system.

I was only bedridden a day or two, but lacked the zip and stamina to play tough matches. So Walter made use of me as both driver for the team and money manager. Ted Schroeder had failed the first assignment by crashing our car—twice—into parked cars. While still in the parking lot, yet!

The money handling was okay with me. I'm a frugal soul by nature. It was easy enough to disburse each player's twenty dollars or so daily allowance for the six weeks we were in Australia. They all accepted this schoolboy sort of thing with humor, except Schroeder, who demanded all his money in advance and hurried to a bank to deposit it for interest.

Ted was quite a character at dinner time, too. We were all steak eaters, and we all ordered our meat broiled different ways, each to his own taste. The first steak to be brought to the table, Ted would grab, even if it wasn't his, throwing the rest of us into an uproar.

We were a headstrong team. Had to be. Walter Pate, our non-playing captain, past middle age and a Wall St. lawyer by profession, didn't know beans about tennis. He felt out of his element deciding who would play for the Cup. He told the six of us to make the selections ourselves.

We hashed it over in somebody's bedroom (don't remember whose). We were split into cliques. Mulloy and Talbert were buddies, as were Kramer and Schroeder. I was an independent. Parker was a loner. We did a secret paper ballot for the eyes of the captain only. Result: Ted and Jack would do the first two singles, and also the

doubles. Jack would handle the third singles, and Gardnar would do the last one.

Frank , Billy, and I would be spar mates only. Frank was incensed. "I'd have stayed home if I'd known I wouldn't be playing," he stormed. Billy, ever the diplomat, was philosophical. As for myself, I was disappointed, yes, but also realistic about the draw, being the new kid on the block.

All along, I felt our team would win. Despite what the Australian press was touting—Aussies to win 4 to 1, or even 5 to nothing.

Betting is legal in Australia. I laid a bet on our side through Bob Barnes, one of the top Aussie players and son of a bookmaker. Four hundred dollars on the nose, I put down. Bob, impressed, I guess, by my confidence in my teammates, bet the same. But he panicked at the last moment, believing the crowings he was reading in the Aussie press, and reversed the bet to his own country's team.

Well, the United States won. And flat out, as the Aussies say. I got back a nice tidy eight hundred dollars. Poor Bob was known forevermore as "Cold Feet Barnes."

By the way, our bumbling Ted Schroeder was a genuine hero in the Cup matches. He won a very hard-fought match against Bromwich, the expected winner, in the opening round. It went five sets. Ted lost the first, and the fourth, but finally pulled out the win which put the kibosh on the Australian team, Bromwich having been considered indestructible. The other defending Australians were Dinny Pails, Adrian Quist, and Colin Long.

The Cup came home, but I stayed on, as did Talbert and Mulloy, to play the Australian Nationals. (The rest of them flew home.) We did a barnstorming tour, splitting up to play exhibitions with Australian opponents all around the country. And I mean country! It was bush—really small towns with courts in the darnedest places, on top of windy hills for instance. They were clay courts, which would be watered heavily before we played. Some parts of the court would always be missed so they'd be like stone and you'd skid like mad. Or the court would be over-watered and be like mud.

My traveling companion/competitor/driver was Billy Sidwell. Like me, he was an alternate on his country's Cup team but had not been called on to play. We played ten different places in ten days, plus some night play, where the lights would be blinding on one side of the net and missing a light or two on the other. Billy was very forthright about all this; after all, he worked for Slazenger, which promoted the tour and paid our expenses. We drove through many sheep crossings. At one of them, our car hit a sheep and Billy took the animal on his lap, stroking it, cooing to it, feeding it water. When the sheep seemed pretty well recovered, we turned it loose.

It wasn't all work (if you call tennis "work"). I went lingerie shopping one day with Talbert. He wanted to buy a nightgown for his lady. "How about this?" he asked me, holding up a frilly, pink old-fashioned job. "Aw, no, not glamorous enough. I bet she'd love this one," I said, pointing to a coffee-brown slinky satin number. (Later I heard that she loved it all right. She married Billy not long after.)

At the Australian Nationals (it wasn't an Open then), I got as far as the semifinals, losing to the number-one seed, Dinny Pails, who went on to win the championship.

In late January, 1947, I flew home to San Francisco and the reality of seriously resuming studies at law school. Night and day, quite a grind. On a Thursday in June, I took my finals for the spring semester, tossed the law books in the closet, flew to London, and the following Monday was on the courts at Wimbledon for the 1947 contest.

This time I took a duffel bag full of food. Through the courtesy of the Wilson Meat Packing Co., parent company of Wilson, my racket makers, I carried forty-four pounds of choice steaks packed in dry ice, guaranteed to last up to forty-eight hours upon arrival in London.

After checking into the Rembrandt Hotel, my first order of business was to deliver the meat to the chef for the deep freeze, with my name on it, of course. Not long after, Harry Hopman, then coach and mother hen to the Australian contingent, knocked on my door.

"They say you brought your own food," he said to me. (Besides the steaks stashed safely away in the kitchen, I had graham crackers, dried apricots, dates, salami, cheese, blackberry jam, etc. out in the room in plain sight.) Harry seemed interested and his approval was evident. "You look very fit," he said to me upon leaving.

The extra sustenance didn't do me all that much good. I was seeded number three, Kramer was number one, and Bromwich number two. Out of practice for almost five months and very rusty, it was nip-and-tuck getting through the first round against South Africa's Eric Sturgess. It was a rain-plagued tournament, hard on all the players, of course.

Our match was tied at 2–all in the fifth set. Eric broke my serve. It was now 3–2. Up till then, he had been playing the back court regularly. Suddenly he changed his game, figuring it was time to go for it. Bad mistake. Four times he served and ran to the net. And four times I hit clean passing shots. Now the score was 3–all. I pressed on, got some let balls at the right time, and felt lucky to pull out the win at 8–6 in the fifth.

Each day I got a little better. I managed to beat Australia's Colin Long in another five-setter. Although in nearly complete control for three sets, Colin wilted under a combination of a rare blazing hot London summer day, and a determined me. I put on a swift, shattering attack, using my most severe ground strokes, won the fourth set with just one loss of game, and the fifth at love.

That put me versus Yvon Petra, the reigning Wimbledon champion who had eliminated me the previous year. I talked a lot to myself in this one, having firmly decided not to let up as I had before. Petra was not playing all that well. (I later learned he had had foot surgery earlier that year.) I kept the pressure on steadily, made him run all over the court, and was able to pass him when he got out of position. A great win for me: three straight sets.

That led me to my old pal, Budge Patty, who, despite a pulled leg muscle, had beaten Jaroslav Drobny the day before in a storming, relentless four-setter. Again, I was on Centre Court, and though

Budge got off to a faster start, we had a rip-roaring steady go at it, with lots of volleys, and I prevailed—6–3, 6–3, 6–3.

This got me to the finals against Jack Kramer, the expected heir to the throne. King George VI, Queen Elizabeth, and Princess Margaret were to be in the royal box that Fourth of July. The King and entourage were forty-five minutes late in arriving. Separately, Jack and I had asked Pancho Segura to warm us up for the match. He agreed, but he never showed. You don't like to warm up with the guy you're going to play. It tips your hand as to where you are that day. But we were stuck. Time was short. So we did.

And the King had not yet arrived.

Jack and I went back to the locker room to wait, pace the floor, and wait some more. We didn't say much, if anything, to each other. Just waited for the summons to get out on court.

The royals, once they got there, witnessed a match for the record books. It was one of the shortest men's singles finals in Wimbledon history. Jack positively blew me off the court in forty-five minutes flat—6–1, 6–3, 6–2.

(We were not the shortest finals, I hasten to add. According to Wimbledon historian, Alan Little, William Renshaw back in 1881 whipped John Hartley in 37 minutes. And in 1936 Fred Perry took out Baron Gottfried von Cramm in 40 minutes.)

Our match wasn't as bad as it sounds. Jack was, in a word, awesome. That unique service of his—mostly at three-quarter pace, spun wide to the backhand, but occasionally spiced with full pace—won the day. My favorite shoulder-high forehand volley crosscourt was not enough. I would like to think I was a worthy finalist. That I did as well as any player could have that day.

They tell me Jack leapt the net to receive my congratulations and that I shuffled up slowly to meet him. I cannot dispute it. The match was a blur. But I did get to meet the King, Queen, and Princess, and that, at least, was a thrill.

With Margaret Osborne, I played the mixed doubles semifinals. So, in retrospect, Wimbledon '47 wasn't all that bad.

At the French Championships that summer, my singles perfor-
mance was pretty feeble, but my doubles was better. Paired with Bil-
ly Sidwell, my post-Davis Cup Australian touring companion, we
played the finals opposite South Africa's Eric Strugess and Eustace
Fannin. They won.

Before leaving Europe, I had two experiences in Czechoslovakia
I'll never forget. I had gone there to play exhibitions with the Czech
champion, Jaroslav Drobny. Now, Drobny was one of the wonders of
the world. He had played forward on Czechoslovakia's Olympic ice
hockey team, so you could see right away he was tough as nails. He
had a build you would have thought was impossible for tennis. He
was thicker at the bottom than he was at the top. But he was as fast as
a striking snake when it came to hitting the ball. You'd send a lob
high over his head. He'd jump up in a compact mass very swiftly, un-
coil, come back with his left hand and put the ball away for a clean
winner.

There was only one ballboy, a little guy, all wizened up and kinda
hunchbacked. But he was all over the court, knew where the ball was
going to land every time and would scuttle over and retrieve it and
have it back in the player's hands just like that. He was the quickest,
most deft, most alert, best ballboy I've ever experienced. Wanting to
thank him and give him a tip, I asked Jaroslav for his name. Jaroslav
beamed broadly. "He is my father!" he said.

There was excitement in the streets of Prague that night. A good
excitement, not at all threatening. I strolled outside the hotel and
found a spontaneous street dance going on. The music was catchy, to
put it mildly. A lovely young woman seized my hand and pulled me
into the circle. Turned out it was a celebration by the Jewish com-
munity, for the United Nations had just officially announced that Is-
rael could become an independent nation. Every time I hear that
haunting melody, "Hava Nagila," I think of Prague.

I was still on a high upon return to the States, with just a few tour-
naments left to play. Didn't do so well in the National Doubles. Bob
Falkenburg and I teamed up but were put out in the second round

by Vic Seixas and partner. In the National Singles, I got to the finals—and who did I face? Kramer again! And I was beaten again, by "sizzling crosscourt volleys that danced tantalizingly" away from me, to quote my favorite tennis writer, Allison Danzig.

At the end of 1947, Jack Kramer, at the age of twenty-six, turned pro for an awesome sum for those days, $50,000, the amount to be re-negotiated each year. I was invited to join him and Bobby Riggs for the tough life of one-night-stands all over the country. I never even considered it, so intent was I on a legal career.

So it was back to the law books until the next summer.

Wimbledon, 1948, was my swan song. There's a tradition there that the previous year's men's singles champion has the honor of opening the tournament by playing the first match on Centre Court.

Because Kramer had turned professional, and Wimbledon did not yet have "Open" play as now, the honor fell to the amateur runner-up, me.

There was a hell of a rainstorm that day. They had a unique kind of weather signal over there to keep players informed. You learned to watch the flagpole posting of a black ball or a white one. Black meant rain coming or present; white indicated an all-clear sunny day, with play proceeding on schedule. But even if it was raining the white ball might be on top, for seldom at Wimbledon does rain last long. Tarps are pulled over hastily to shelter the most important courts, and are whisked off just as quickly for play to resume.

Finally, my match began versus Don Butler, a virtually unknown Brit. And I damn near lost it! I was within two points of defeat before finally gaining control of myself—5–7, 6–1, 4–6, 6–2, 9–7. Having been such a nose-in-the-books student, this was only my third grass court game of the year, and I had difficulty getting the feel of the surface.

It was also rather distracting to have a public relations assignment hoisted on me by the mayor of San Francisco—a friendship scroll to be presented in person to the Lord Mayor of London. I sure could have used that precious time for tennis practice.

Anyway, I struggled along, winning the fourth round against Indian Davis Cupper Dilip Bose. But I was put out in the fifth by a human backboard, the Hungarian champion, Josef Asboth. His mode of play drove us all nuts. "Mr. Monotonous," they called him.

Doubles was a lot better. Teamed with Gardnar Mulloy, we played two more Davis Cup players from India, Sumant Misra and Subh Sawhney, in a tight third-round five-setter. (Half a century later, I was to meet Sumant again under amusing circumstances on his own home turf in New Delhi.)

Gardnar and I came up against John Bromwich and Frank Sedgman in the finals. (Where this book began with me in the wings, waiting to go on.) We did not win, but it was close: 5–7, 7–5, 7–5, 9–7.

Back in the U.S., at the National Doubles at Longwood, I had the satisfaction, with teammate Irv Dorfman, of defeating my old adversary, Drobny, and his Davis Cup partner, Vladimir Cernik. We also put out a newcomer; you'll have heard of him, of course: Richard (Pancho) Gonzalez.

We played the doubles quarterfinals in 103-degree heat. Poor Irv just about passed out, but we gave Talbert and Mulloy a run for their money—three hours, four long sets.

As we sat there toweling off afterwards, I poured a pitcher of ice water over Irv's head. An AP photographer caught the moment, which was published all over the country the next day.

At Forest Hills, my singles exodus was due to my old buddy, Nick Carter, from San Francisco's Golden Gate Park. But I won the mixed doubles title of the U.S.A. with my favorite woman player, Louise Brough.

Getting to this win was even more fun than the win itself.

In the finals, Louise and I came up against the team expected to win, Billy Talbert and Margaret Osborne (before she became du-Pont). It was deuce on Billy's serve, and the game for the match.

Billy put in a hard first serve. Louise could only throw up a high lob in defense. Billy ignored it, expecting the ball to fall outside the

court. Instead, it dropped down and struck him on the shoulder. I re-member Margaret giving Billy quite a dirty look for not getting out of the way.

This made the point ours. Ad-out went the score.

We won the next point on my service return. The game and match were ours.

And back I went to my law books. But there'd be intermissions....

# *Third Set*

# 9. Family Matters

"A TENNIS PLAYER begins wearing out at twenty-eight, and, with a few exceptions, is pretty well worn out by thirty-five."

That's what I said in 1951, folks. I was twenty-nine, and had all the best intentions of shelving tennis and devoting full time to being a lawyer.

I'd been tapped for the second time for the Davis Cup team just the year before—the United States versus Australia, a challenge the U.S. lost 1–4. (It was I who scored the only win—a singles against Ken McGregor.)

In 1950, I won, with Art Larsen, my first U.S. National Hardcourt Doubles. In '52 and '53, Tony Trabert and I teamed up to win the same title in Salt Lake City, Utah. We were a fateful duo, for look what happened. The tournament committee was looking for publicity, and naturally they sought Tony first—he being the current National Singles champion. They wanted him to pose for a picture with Miss Utah, a very attractive young lady. They couldn't find him so they asked me, the second seeded player, to do it. She was very agreeable and easy to get along with, so I dated her up for the next evening.

But I found I was scheduled to fly back home to my job in San Francisco, so I asked Tony if he could take her out instead. He did, they liked each other, and were married not long after. Unfortunately for marital happiness, he was about to turn pro, which, in those days, meant touring to maybe fifty different locations a year. Very hard on a marriage. They did, however, manage to have two children.

Tony played an instrumental part in my love life, too. On one of his trips to Australia, he met a young Canadian named Robbin Whitelaw, who was a stewardess on the flight. He asked her where she was based. When she said San Francisco, he told her to be sure and give his good friend, me, a call when she got back.

She did, and a romance quickly ensued. I felt I was overdue for marriage, she was of the same mind, so we were married very shortly. Unfortunately, we never had much in common except a physical attraction when I was thirty-four, and she twenty-two. The marriage lasted just long enough to give us four wonderful children, Mark, Wendy, Sue, and Sally.

Of all my children, only one has no interest in tennis. That would be Sally (Mrs. Scott Jessen), my youngest, of Cool, California. She is plenty sporty in other ways. She has won national championships in race car driving, enjoys (or used to) free-falls from airplanes, has horses, dogs, cats, and a boat.

When Sally was about sixteen, I took her on a tournament trip to Maui, Hawaii. She met one of my tennis compadres in a most unusual way. We were acquainting ourselves with the hotel's facilities and as we approached the swimming pool her eyes flew open with a startled expression. She saw before I did a shaggy, bearded man in swim trunks running toward us who, with a whoop, jumped joyously into my arms. It was the Danish star and free spirit, Torben Ulrich.

My son, Mark, of San Ramon, California, is a sales manager for a top manufacturing firm. He was enough into tennis in his younger years that we entered and reached the semifinals in a National Father-Son Championship. Alas, at the time of this writing, he has little time for tennis, with two growing children and a preference for water skiing and boating, but he tells me he hopes to get back into it.

Mark is a fine physical specimen, tall, dark, and well set up in every way. I took him to Palm Springs, California once, on a tournament trip. In company with some of the other players, I had settled into the hotel's whirlpool late one afternoon. Mark was the last to arrive and as he sank, muscles and pecs rippling, into the billowing

clouds of steam, Fred Kovaleski wryly commented, "Say, Tom, when was the last time you spanked him?"

My oldest daughter, Wendy, (Mrs. Tory Yaphé) is a teaching vet on the Caribbean island of St. Kitts, and a mother of two. She does triathlons, but is also a darn good tennis player and has won a couple of Caribbean Championships.

Daughter Sue (Mrs. Christopher Phillips) lives in San Diego, California. She is a doctor, an endocrinologist specializing in diabetes, at the University of California Hospital in San Diego. She actually worked as a tennis pro briefly, but has since turned her sportive energies into running nine miles a day to keep fit. She has two children. Sue tells me she hasn't played serious tennis for years. One of those years I took her to a tournament in Lakeway, Texas, where Vic Seixas enlisted her as a practice buddy.

Among my four children, I have six grandchildren. None, as of now, seem tennis-oriented. But give them time. I am not in favor of parents (or grandparents) pushing a child to go further in any endeavor in which they do not seem to have a natural interest.

My children tell me they were never jealous of the time I spent on tennis. "Go for it, Dad!" has been their attitude from early on. As they grew up and began traveling on their own, a kind of catch phrase developed among them, as they realized tennis can be a shortcut to having a friend almost anywhere. "Who do we know there, Dad?" they would ask.

Recently, Sue confided that when she was in the fifth grade a teacher remarked to her as she took her seat in class, "Your father is famous."

"He is?" Sue responded, quite puzzled.

"Yes," confirmed the teacher. "He did very well at Wimbledon."

"What's Wimbledon?" Sue asked the teacher.

"I honestly didn't know," Sue told me, "because you'd never told me about your big achievement at that famous place. Mother certainly wasn't going to tell me. So I had to hear it from my teacher, how great you were and how respected."

Aw, gosh, what's a dad to do except glow at words like that!

Mark told me the other day that tennis has played a significant role in his life. "Tennis folks you introduced me to were always enjoyable to be with. Warm, humorous, and kind. I remember you taking me to Lakeway, Texas, and Cliff Drysdale, the pro there at the time, going water-skiing with me. That was very exciting for me.

"The most memorable trip was going to Wimbledon with you, and mingling with top tennis players. Having a player's badge, I was truly on the inside track. I remember accompanying you into the locker room as you changed for your upcoming match, and running into several tennis greats who we chatted with—Rod Laver, Roscoe Tanner, Roy Emerson, Bjorn Borg....

"I remember arriving at the tennis grounds in our limo, where we were mobbed by fans. Many approached me for autographs. Although I tried to explain that I was not one of the players, it was just easier to acquiesce and sign many programs. To this day, I wonder how many folks have an autograph from Mark Brown and wonder how many dollars it might bring in today's trading community."

Mark confessed to me while I was writing this book that as a young teenager he felt scared being left in the house alone when I traveled. This was news to me—he always, as a teenager, put on such an act of bravado! I pressed him for details.

"The house on Fourth Avenue had three stories, remember, and it backed up to a dark and untraveled alley," he reminded me. "The house creaked and groaned quite a bit. Alone at night, the noises and the proximity to the alley caused my imagination to get the better of me. I installed several locks on my bedroom door, and also locked the door between the first and second story, but I never overcame my fears. Many times I would go over and stay at grandmother's, where I felt much more secure."

"Gee, Mark," I told him. "I never knew you were scared."

"I know," he smiled. "I didn't want you to. But at least I got to know granny well."

My daughter Wendy, who's a year younger than Mark, recently

With my tennis-playing mother,
Golden Gate Park, San Francisco.
The year: 1928. Age, 6.

First known photo of myself with
a tennis racket.
How do you hold the darn thing?
I seem to be saying.

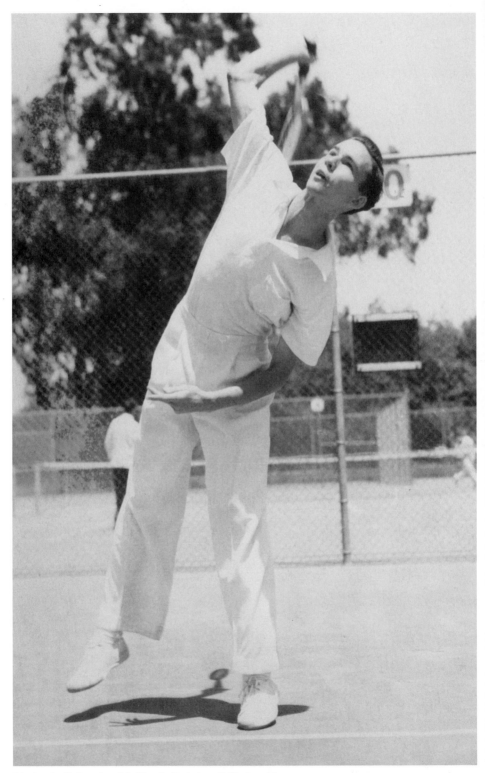

Playing for University of California-Berkeley. 1940. Age 18.

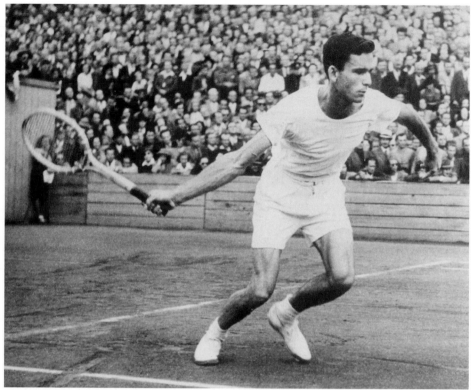

My year of glory, 1946, the Championships at Wimbledon, England. I was 23.

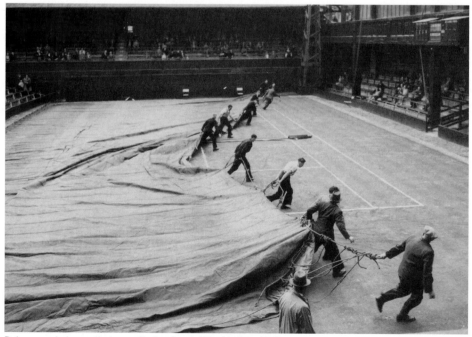

Rain cover being pulled over Centre Court, Wimbledon, 1946.

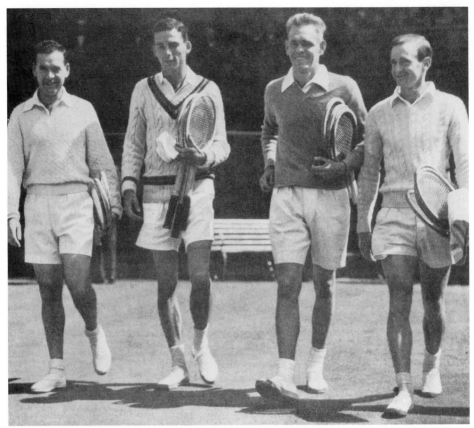

Jack Kramer and I walking onto Centre Court, Wimbledon, to play the 1946 Gentlemen's Doubles Finals against Australia's Dinny Pails (left) and Geoff Brown. We won.

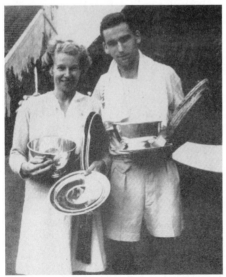

In the royal box at Wimbledon 1947, with champion Jack Kramer, meeting King George VI and Queen Elizabeth.

With my favorite female partner, Louise Brough. This photo is of us winning the U.S. Mixed Doubles title in September 1946. Just two months earlier we had won Wimbledon.

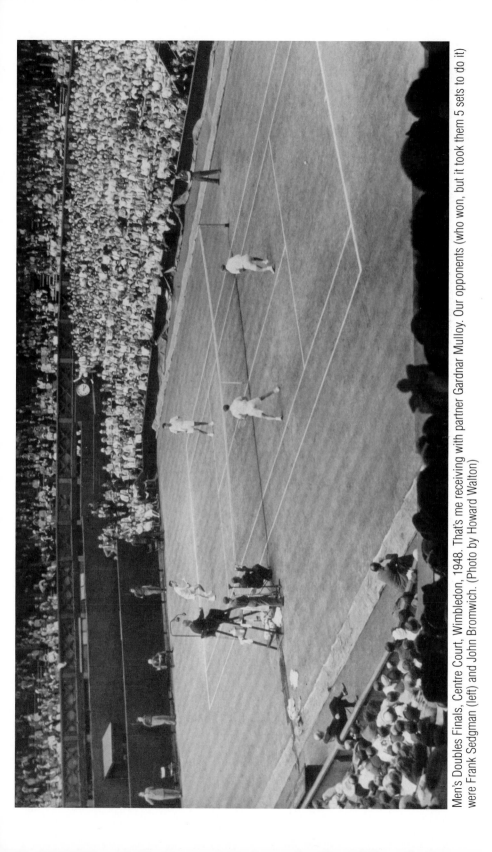

Men's Doubles Finals, Centre Court, Wimbledon, 1948. That's me receiving with partner Gardnar Mulloy. Our opponents (who won, but it took them 5 sets to do it) were Frank Sedgman (left) and John Bromwich. (Photo by Howard Walton)

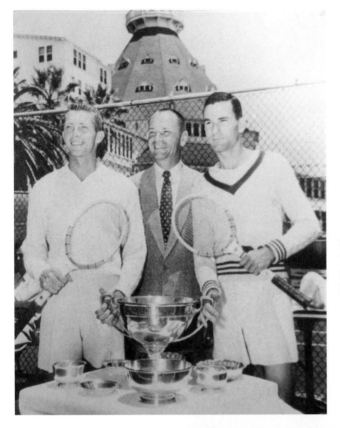

With then-world champion
Tony Trabert, 1950, at a
tournament at the
Hotel del Coronado, California.

In the 1980s,
at a tournament at the
Golden Gateway courts,
San Francisco.
I'm in my 60's here.

At Sugar Bowl Classic, New Orleans, 1956. I'm with Gardnar Mulloy, Alex Olmedo, and Vic Seixas.

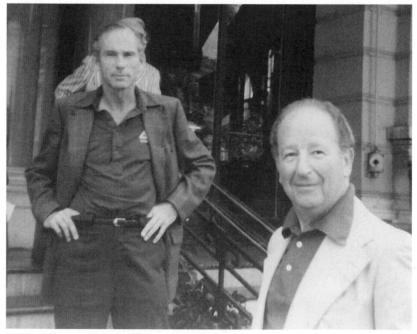

In Monte Carlo, 1976, with famous columnist Herb Caen.

Vic Seixas' "Tennis Fantasy Team", Palm Springs, California, November, 1987. Left to right: Pancho Segura, Fred Perry, myself, Bobby Riggs, Pancho Gonzalez, Vic Seixas, Frank Parker, Tony Trabert, Sven Davidson.

Family vacation in Jamaica, 1980. That's daughter Sally and her husband Scott protectively holding onto me; Wendy and Sue and their husbands behind; son Mark to the right with then-wife Laura in back.

Mark and I teamed in a Father & Son Championship in 1983. I was 61. He was 25.

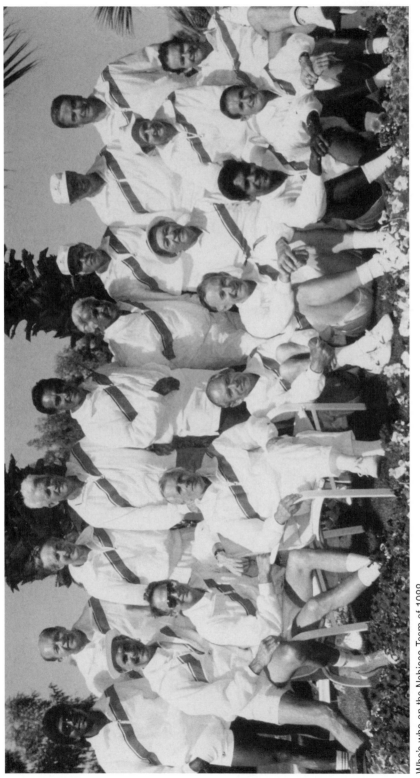

Who's who on the Nabisco Team of 1988.
Back row, left to right: V.J.Amritraj, Ron Holmberg, Straight Clark, Gardnar Mulloy, Alex Olmedo, Pancho Segura, Tony Vincent, Frank Sedgman, Vic Seixas.
Front row, left to right: Sven Davidson, Gene Scott, Frank Parker, myself, Fred Kovaleski, Bill Talbert, Anand Amritraj, Rod Laver, Mal Anderson, Cliff Drysdale.

Wimbledon reunion, 1989, with my former mixed doubles partners, Louise Brough (left) and Margaret Osborne.

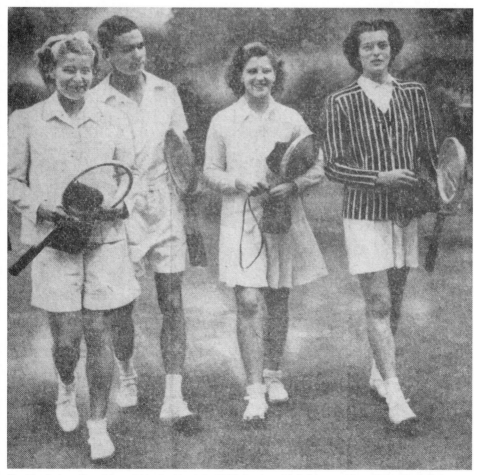

Flashback: how the girls and I looked back in 1946. Louise at left, Margaret in middle. That's Pat Canning Todd on the right.

In India in 1998 with Mahindar Singh (left), Barbara Scofield Davidson, and friend.

On my own at Machu Picchu, Peru, 1998.

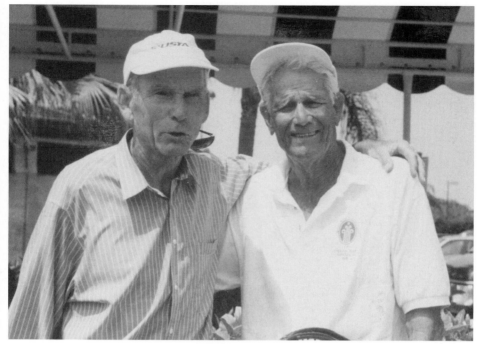

Palm Beach, Florida, 1998, with Gardnar Mulloy.

Reacquaintance with Pat Canning Todd at the National Senior Hardcourts, Rancho Santa Fe, California, 2002.

San Mateo, California, 2004. Exercising new knee with physical therapist Sue Koch.

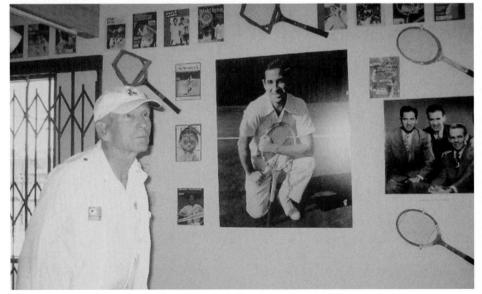

Visiting the Bobby Riggs Tennis Museum in Encinitas, California, 2006.

Wimbledon reunion, 2006, with Bill Sidwell of Sydney, Australia. We first met when we were on our respective countries' Davis Cup Teams when we were in our 20s. Here we are in our 80s.

In the stands at Wimbledon, 2006, with old friends Lee Tyler and Pancho Segura.

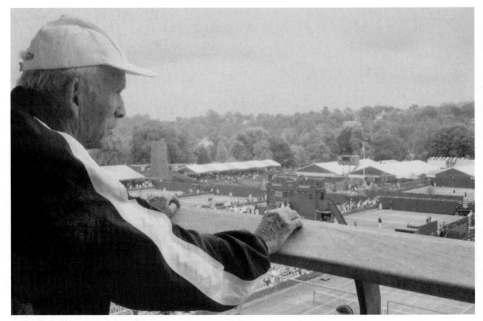
Wimbledon, Summer of 2006. Looking back on a lifetime of tennis.

wrote me quite a marvelous letter about what tennis has meant to her life. Let me share some of it with you.

"In my formative years," she started, "tennis was not looked upon as good or bad, but just part of the scenery of life in my world. I recall little snippets of pictures in my mind of tennis courts, hearing balls go back and forth as they were hit, of the sunshine you frequently encounter at tennis courts, of being a member of an audience in a stand at Golden Gate Park and the like.

"I did not really ruminate on the fact that this was not a part of *everyone's* life until it dawned on me, at age eight, or nine, or ten, that not all parents played tennis. And then I came to realize that you didn't just like to play tennis, but were quite good at it.

"To us kids, tennis meant weekend trips to great country clubs, warm places to lie in the sun, swimming pools, hamburgers, ice cream, and a weekend with you, who, for the most part, were always in good humor and pretty easy going.

"While all of us occasionally hit balls with you, it wasn't until I was about fourteen that I started to really enjoy the game and your tutelage. Our family trips were a big highlight of my youth. We would go to Garberville or other locales not far away, and the running shoes and tennis rackets would come along. We would go for runs together in the redwoods, and then you would pack us, and an ice cooler and sodas, into a car to find public courts where you'd take turns with us for lessons or doubles, or some combination thereof.

"As we grew older, the trips became more exotic. I'll never forget the thrill of the trip you took Mark and me on to Nottingham, England, and what an adventure it was to watch top level tennis on grass for the first time. And then we went to Switzerland. Finding a great hotel, hot chocolate, excellent baguettes, and a beautiful clay court, and having the opportunity to play tennis there with you, was heaven.

"What I love about tennis, first and foremost, is that it has given us the opportunity to interact, meet and come into contact with a cross section of humanity that we otherwise would never encounter. Tennis is a great equalizer. You can just as thoroughly enjoy knocking

the ball about with the bakery guy, the politician, the gardener, the school kid, the retired mailman, or the CEO of some corporation…it doesn't matter.

"Without tennis, I'd be more confined to the social circles associated with work, family and regional friends. Tennis makes for similar opportunities when I travel. I always take my racket, and one of my first stops will typically be to the local club or pro, which leads to conversations, introductions, and *voilà*, regional points of interest, travel tips, food tips, etc.

"I also love tennis because of the lifelong satisfaction of mastering the skills for certain elements of the game. No matter how accomplished you become, there is always improvement to be made. It's a constant challenge to get better. I do not know if I will ever be as successful as you, Dad, in this regard, but from a physical standpoint I enjoy the game immensely. If I had to pick a perfect day for myself, it would include family, good food, and a good tennis workout. I love the exercise, hitting the ball, working on spin, strategy, making my opponents run, and the benefits that come from physical fitness. Without the sport, I would be much less effective in my work life as well as my family life.

"One of my biggest dreams and goals as a parent is to have my own kids realize the same joys and benefits of tennis as they, too, go from youth to adulthood. Alas, perhaps I am less patient and less wise than you were. You really waited with us until we wanted to play. But I am so hopeful of having a lifelong partner with the game that I, too often, encourage the kids to come out and play. They have both been exposed to the game but just do not have a significant interest in it."

Well, Wendy, don't give up on them. Just cut them a little slack!

# 10. Lust for Travel

I THINK I HAVE ALWAYS had wanderlust. It must have been inbred in me. Certainly an early influence was accompanying my mother when I was nine on a vacation trip to Mexico City. We went sightseeing over that fantastic and not yet smog-ridden capital in an ancient Fokker airplane that sputtered and shook. I was too thrilled to be scared.

As I grew up to be a tennis player, the world was my oyster. I was always able to pick and choose where I'd go and I had three criteria: could my tennis be improved by going there, was it an interesting locale with interesting people, and would my travel expenses be paid?

One of my favorite trips for travel plus pleasure was a goodwill swing through the Caribbean. An invitational thing, it began with the Admiral of the American fleet based in the Caribbean sending a special plane to Palm Beach, Florida to collect our little group, which included Vic Seixas, the then-top player in the U.S.A.; Mario Llamas, the then-champion of Mexico; and the brilliant but quite odd Herb Flam. My seatmate was the adorable dancer, Vera Ellen—whom I had never heard of before since I'm not much of a moviegoer. She was modest and charming to talk with, and the flight to San Juan passed much too quickly.

The tournament included Panama, where I played in the noon-day sun and heat without a hat, and certainly no sun block. (We didn't know any better in those days.) In Barranquilla, Colombia, it was very windy and in practice the first day a small group gathered around the court to watch me. I recall swinging at the ball, missing it

completely, and hearing someone in the crowd mutter, "Who does this guy think he is, anyway? We're paying to see *him*?"

Another trip I liked a lot was New Orleans, Louisiana, every December for three years running, to play for the Sugar Bowl. I traveled there from San Francisco by my favorite mode, train. The tournament sent me $400 for plane travel, but since the train only cost $105 I pocketed the difference; and to cut expenses further my mother made many sandwiches for me to eat on the train—egg for the outbound trip, cheese for the return. They were delicious, and even without refrigeration I never got food poisoning.

The tournament was played at a nice club with excellent green clay courts. Mulloy was there, and Fred Kovaleski, Edde Moylan, Mervyn Rose, Tut Bartzen....

The tournament not only put us up, but entertained us with dinner at Antoine's, a tour of the jazz spots, a cruise on the Mississippi River, and tickets to whatever alternate sports we could fit in—basketball, football, whatever we wanted. I have fond feelings for New Orleans, and felt an intense sadness when, nearly fifty years later, Hurricane Katrina hit her so savagely.

Mulloy, Moylan, and I had each won the Sugar Bowl twice. The third time was a charm, the year the winner could take home the Bowl for keeps. Mulloy should have won it; he was easily the best and most experienced player, but his game went to pieces the day he played Fred.

I managed to get past Mervyn Rose, a top Australian player of the day, in five close sets, to come up against Tut Bartzen, then ranked among the top ten players in the U.S. and considered to be our best clay court player. I won that one in three straight sets, and also had a straight set win over Kovaleski, which seemed to surprise everybody. At the farewell banquet dinner, Mulloy looked down the table at me and shouted, "You lucky son of a bitch!" Smiling back, I told him, "Gardnar, I'd much rather be lucky than good."

Words to live by then, as now!

Speaking of words, I was always a rather shy fellow. Throughout

my law years, I was active with the Toastmasters, that worldwide organization that helps you get over self-consciousness at having to speak before strangers (such as in courtrooms). A tool I learned there has proved very useful at tennis gatherings around the world. Repeating a key phrase or a name out loud gives you a moment in time to come up with an extemporaneous (and hopefully interesting) remark.

For a year or two, I was president of the San Francisco branch of the Young Democrats, and dallied briefly with the thought of entering politics. I had a chance once when a seat in the California State Assembly suddenly became open. One of the representatives, well up in years, often fell asleep during proceedings and had to be prodded awake with a darning needle when there was a vote to be taken. This one time he didn't wake up—he had died in his chair.

Instant opening. I ran for it; so did three other guys. I got ten votes, but they outgunned me.

Just as well. The trouble with politics is you always end up owing favors to the ones who put you in office. And I did not want to be beholden to anyone. A congressman I worked for had a secretary who complained to him, "Can't we do something about all the nuts who hang around campaign headquarters?" "Now, Diana," he chided her, "you must remember it's the nuts who elect me."

Lawyers toss business cards at each other willy-nilly. This can backfire. I knew some fellows who had an important case pending before a judge known for his correctness. They sent him a gift box of oranges. "Geez," I reacted, "he'll rule against you, for sure." "Not to worry, Tom," I was told. "We put the other guy's card in the box."

As I pursued my legal career, it was obvious that if I wanted to juggle time-outs for tennis, I'd have to go into business for myself rather than depend on an employer's regular checks and good graces. I was always a civil lawyer, never interested in the more lucrative criminal defense field. My working days were mostly involved with trusts, wills, and divorces (the latter never failing to trouble me, since my own marriage was on the rocks). In the beginning, I did

collections a lot. Didn't like it much, though it did familiarize me with sleazy sides of San Francisco I'd have never known otherwise.

A young lawyer has to take cases nobody else wants. I had my fill of domestic squabbles. Like the irate wife who threw her husband out of the house, and was requested by her lawyer and his (me) to at least give him his clothes. "All right," she agreed. "I'll put them outside the door Tuesday morning, and he can pick them up."

What she didn't tell us was that Tuesday was garbage collection day. And, you guessed it, she piled his clothes on top of the cans, and out they went with the trash.

During my legal years, I did strike one significant blow for my fellow man. In California law there is what an attorney friend of mine calls "Brown's Amendment." It declares that if an ex-wife is living with another man, she cannot collect both alimony and child support from her former husband.

As my children grew older, so did I, and opportunities to satisfy my lust for travel with tennis were frequent and wonderful. Being over forty-five, I found, had a great advantage. I was invited to join the Grand Champions tour. The founder, Al Bunis, was only a fair tennis player but a fine tournament manager. He was very amiable and a keen judge of tennis flesh. He supplied a new concept made up of has-been's—players who *had* been world champions but no longer were. He believed there was a public who would pay to see our games, in both singles and doubles, in slightly slower motion than the younger players who were winning the top championships of the moment.

Al and the troupe, of which I was a rotating member when my law cases allowed, traveled all over the U.S. and Europe, playing ten to fifteen tournaments a year in an eight-man draw. We lasted about three years. Al eventually sold out to another entrepreneur who had a newer venue team, because as forty-five-year-olds become fifty, they're not so much of an attraction.

But while the going was good, what trips we had as the "Grand Champions"!

Fast forwarding to the 1970s, the Tennis Grand Masters came along. What a traveling troupe *that* was!! There were maybe twenty of us who had a good record of big tournament wins, including a bunch of Wimbledons. We were seasoned competitors, yet darn good friends.

One of our most memorable trips was to Hong Kong. Our tournament was sponsored by a group of the wealthiest men in the then-crown colony. Democratic touch: we played on public courts in Victoria Park. But at night we would turn into Cinderellas and be chauffeured to one of the hosts' palatial homes, where waiters would hover with silver trays and guards were posted in every room to protect the valuable artwork. At one of the fancy banquets, I lucked out with a seat beside Miss Hong Kong. "Are you all Chinese?" I had the temerity to ask her. "Not all," she confessed. "About eighty percent. I am also French, English, Vietnamese, Thai, and a few other things."

Since Frank Parker and I were the oldest in the group, we usually teamed in doubles. Frank was very much a gentleman, a droll fellow. The boys in the locker room liked to kid him. "Gee, Frank, you sure have a beautiful pair of legs." He'd let a slight smile grow and reply, "Yes, and they can be had, too."

Frank had a long and devoted marriage to Audrey, who had formerly been his stepmother when she was married to Mercer Beasley, Frank's adoptive father and boyhood coach. Frank's faithfulness to Audrey was legendary. Once, when he was the lone house guest of a friend of mine in San Francisco, his host wanted to show Frank some of the lively night life of the city. Frank begged off. "Oh no, I wouldn't want to do anything like that without Audrey being with me, " he said. My friend thought that was very touching.

The Grand Masters wasn't really a test, because we were all over the hill and didn't play competitively all that much. Yet, there'd be moments when the old talents would flash through. As Fred Perry used to say, "Many a fine tune's been played on an old violin."

I was in a car once with Fred, Bobby Riggs, and Pancho Segura,

rolling to some Grand Masters affair, when Bobby asked Fred how it used to be in the thirties going on tour with Ellsworth Vines. That tour, Fred told us, was like an animal act. Two players of lower rank would come out and warm up the audience with a one- or two-set match. Then the main guys—Perry and Vines—would come on. They'd play at night.

The way Fred told it, Elly's serve was incredibly fast and hard to see, especially under lights. They would play in any forum they could get, which, more often than not, was a basketball court on which lines simulating a tennis court would be hastily painted. The hard-wood floor was slippery, and the ball would bound off the surface much faster than off a regular tennis hard court.

"It was very frustrating for me," Perry told us. "Embarrassing, too. Not only would Elly ace me repeatedly but the ball would zoom past me and I could barely get my racket up to make even a token effort. Sometimes the ball would go by so fast it would bounce off the back wall and hit me in the fanny.

"I finally got infuriated and went out to a new site in the afternoon when the workmen were painting the temporary court lines. 'You've got the service line wrong,' I told them. 'It should be six inches shorter than it is.' So they painted the lines over to my specifications, and when we got out and played that night I never saw Vines serve so many double faults. He was so mad at his famous serve failing him, that I didn't tell him what I had done until two weeks later."

Torben Ulrich was one of the "Masters." He had a goatee beard and long wild hair which he'd tie back in a pony tail. He lived in Copenhagen, and when we were playing there once he invited me to stay at his home. When I stepped off the plane, he was there to meet me, and said in his understated deep, slow voice, "Would you like to see a bit of Copenhagen before you settle down?"

"Sure," I answered, thinking we'd probably take a short sightseeing drive around town. I'd just come off a long transatlantic flight, but a little sightseeing was okay with me.

"All right," he said. "Put on your warmups and your tennis shoes

and I'll meet you at the front door in ten minutes." I dutifully complied.

"The Royal Palace is only about ten minutes from here," he said. "And there's a nice view of the harbor. There's a trail we can take. It's for horses, but people can use it for jogging. Let's go." So he took me running along the horse trail and we saw all the sights he had promised, as well as the famous mermaid. We were gone about an hour; it was great. I got a prime tour on foot.

Torben, who was also music critic for one of the Danish papers, had a son, Lars, who was deep into heavy metal music. The second night I was there, we were sitting around talking about eleven o'clock at night when Lars, then twelve years old, came over, said something to his dad, and went out the door.

"Where is he going?" I asked Torben.

"Downtown, to his favorite amusement park, Tivoli."

"But Torben, is it safe to turn him loose?" I asked, thinking of the after-dark dangers in my own hometown, San Francisco.

"No problem," said Torben. "He's going with a friend. They do it all the time. It's perfectly safe."

Lars subsequently took up heavy metal music seriously, and was one of the founders of the famous group Metallica. He played several instruments and scored the arrangements and also handled finances for the group. Years later, I was with Sven Davidson and we ran into Lars on the streets of Los Angeles. "Let's have lunch tomorrow," Lars said to us. "I have a car. I'll pick you up."

Well, the car turned out to be a stretch limo, practically a block long, and Sven and I were duly impressed. Lars has done very well.

# 11. Still Lusting

LOOKING BACK to when I was in my fifties, I wonder how I found time to carry on a law business. Tempting tennis junkets happened often. (Thank goodness I had a great partner to cover for me. Kate Hill was pretty, too.)

Rio de Janeiro, for instance. Several of us shared a suite at the famous Copacabana Hotel. There was Lennart Bergelin of Sweden, later to become Bjorn Borg's coach. Another in the group was the top Brazilian player of the day, Armando Vieira.

Armando loved to mouth American obscenities. He didn't do it to be vulgar. He didn't speak English all that much; he just liked the sound of our swear words. One day the Swedish Ambassador phoned, inquiring for Lennart. Armando answered with "Allo, you son-of-a-bitch." The rest of us made wild hand signals and shouted at him, "For gosh sake, that's the Swedish Ambassador you're talking to." Armando was a pretty quick thinker. Speaking again into the phone, he said "I'm sorry, sir. Lennart has gone to the beach. We will ask him to call you."

There were tennis invitational trips to such far-flung places as Bali, Indonesia, Yugoslavia, Romania, and the Palace Hotel at St. Moritz, Switzerland. On a long trip to South Africa, my seatmate was Pancho Gonzalez. Although very, very talented as a competitor, he could certainly be a son-of-a-bitch. Personally, we got along amiably enough, although I remember his confiding to me in flight, "You know, I never figured you were any good at all."

On our trips in Europe, Hugh Stewart was one of our liveliest

characters. Hugo, we called him. His favorite country was Italy. He couldn't really speak Italian, but he tried in a lovable buffoon kind of way. Foreigners found him humorous. We would be in a semiformal dining room, standing out anyway being a group of Americans, and pretty soon all the diners' attention would be focused on Hugh because he'd be loud and making silly noises. At first we'd get offended stares, but pretty soon patrons at the other tables would be laughing both at him and with him. And we'd have a very good dinner with excellent service, for Hugh would put the waiters at ease too.

Clown though he was, Hugh was a fine player. In his time, he won the tournament at Monte Carlo, played very well at Wimbledon and the French Championships, and was ranked several years as one of the best players in the United States, between five and fifteen.

Another Italy trip stands out in my mind. In 1997, when I was seventy-four and he eighty-three, Gardnar Mulloy organized a pro-am for both men and women at a very swanky club halfway between Rome and the Italian Riviera. One evening there was a fancy dinner-dance at a lovely villa. It was very romantic. The tables were all set with candles. That was the only lighting. An orchestra played, and at each of the four corners of the courtyard a marvelous Italian tenor belted out songs. I was a little late getting there; I was alone, and was shown to the only empty space remaining.

Earlier that day, I had seen most of the players warming up on the courts and had noticed a particularly lovely woman who was a left-hander and had very good form. I was delighted to find she was my unexpected table mate that evening. I turned to her to introduce myself. She looked familiar and said she knew me. I finally got her name. It was Jennifer Hoad, Lew Hoad's widow. (Lew had died of leukemia three years before. He was only fifty-nine.)

Pretty soon Jenny and I were talking and became quite amiable. "You may not remember the first time we met," she said. "It was when you were down for the Davis Cup. I was twelve years old and very curious to see the American players. So my girlfriend and I

found a hole in the fence and climbed through it and up to the top of the stadium and watched you play."

Was I flattered? Well, I should say.

After a Grand Masters in Johannesburg once, a bunch of us took a safari together through Kruger National Park. Beppy Merlo was there, and Don Budge, Pancho Gonzales, and Frank Sedgman.

Frank was a quiet type, a hard worker, good-natured and easy going with a nice sense of humor. When he was asked to perform or give an account of himself, he would sing "Waltzing Matilda." He knew all the words. We enjoyed that, and would join in with him on the chorus.

Sedgman not only had great eyesight in timing the balls on a tennis court; he had a better eye for spotting wild game than the guide who was conducting the tour. Frank knew human nature, too. Once when he was about to play one of the top players at Wimbledon, he noticed that his opponent had some romantic entanglements. Frank spotted him ducking up and down the stairs of the clubhouse, looking harassed, each time emerging with a different luscious female. "I don't think I'm going to have much trouble with him today," Frank thought to himself. Sure enough, Frank scored a straight set win.

Closer to home, I enjoyed participating in Vic Seixas' "Tennis Fantasy Week" in Palm Springs, California. This was a one-time affair. Vic organized ten or twelve of us who had been big names once to fly in and stay for a week at one of the plush resorts and give clinics to vacationers who'd pay a lot of money for the experience of being taught by and rallying with a "name pro."

This Palm Springs "Fantasy" set the stage for the Nabisco Team coming into existence. This was a once-a-year event organized by Fred Kovaleski and scheduled along with the big annual Dinah Shore-hosted golf tournament. The golf people liked to offer their customers and players' wives tennis in the form of entertainment and free lessons from well-known players (us). These were very fancy affairs. I played on the team for about six years, along with such other friends as Fred Kovaleski, Gardnar Mulloy, Pancho Segura,

Vic Seixas, Frank Sedgman, Pancho Gonzalez, Straight Clark, Sven Davidson, Billy Talbert, VJ. and Anand Amritraj, Alex Olmedo, Tony Vincent, Ron Holmberg, Gene Scott, Frank Parker, Rod Laver, Mal Anderson, and Cliff Drysdale.

What a dream of a time they gave us! Each one of us, and whatever family or personal friend was accompanying us, would be given a Tiffany watch which doubled as our I.D. when coming through the gate. We'd just flash our wrist and stroll right into the grounds. There was a tent where you could load up on Nabisco goodies. Anything chocolate has always been my weakness. Cashew nuts, too.

I got all three of my girls in on this treat in various years. It was great. In the evening, there was special entertainment for us. Dinah Shore herself, and Bob Hope, and Frank Sinatra.

And then there was Las Vegas. The comedian Alan King used to host the Grand Masters once a year at Caesars Palace. Among the participants were Dick Savitt and Tony Trabert. A costume ball was part of the week's festivities. I'll never forget the year Dick came in a tennis dress, playing the tennis guy who had had his sex changed from male to female that year—Renee Richards. Tony came as Renee when she was a he.

When the band began to play, Savitt went over and asked Trabert to dance with him. Seeing these two behemoths pushing each other around the dance floor was a sight that either made you laugh or cry.

But it was I who won best prize for costume that night.

I went as a turkey.

## 12. Name Dropping

EVERY NOW AND THEN, certain tennis personalities cross my mind. Here are some of my lasting impressions of persons both dead and alive.

**Allison Danzig** A very fine tennis writer for the *New York Times.* Top writer of his day. Tennis got a lot of press in the 1940s and '50s, especially for events like the Davis Cup, Wimbledon, and our Nationals. All the players respected Allison because he wrote stories of matches the way they were. He was unfailingly realistic, honest, and factual. He saw a lot of things in depth that other tennis writers didn't. He knew the players and he understood the game.

Most tennis writers of the day were fanciful. Jim Burchard, for example, was a nice enough fellow personally, but wrote in an exaggerated style. For instance, learning that Bob Falkenburg had played poker the night before a finals match that he lost, instead of reporting the match honestly, Jim zeroed in on the poker game, writing, "Wimbledon champ trips on a deck of cards," or some such silliness.

I don't have much respect for today's press. They have no consideration for a gladiator. If a guy is down, they pounce on him immediately. The press loves to prey on a loser when it's an important match.

**Charles and Mary (Hardwick) Hare** They were both top tennis players in their divisions in England, and England's top tennis couple as far as love was concerned. When they were at a dinner, and the speeches got a bit heavy, they would do a discreet disappearing act.

She'd catch his eye and be the first to take leave of the table. He'd wait a respectable two or three minutes, and all of a sudden his chair would be empty too.

**Frank Kovacs** Not for nothing was he dubbed the "Clown Prince of Tennis." He was six foot three or four, and had a marvelous natural ability with a magnificent serve and fine ground strokes. He was one of the few players who could step around his forehand, take a high backhand, and hit it with a great big stroke to either side of the court for a winner. He had a good sense of humor, but on one occasion that I know of, he lost out. That was when he said to Don Budge one evening when we were all at dinner together, "Don, how does it feel to have the second best backhand in the world?" Budge was not long in answering. "You oughta know, Frank."

Kovacs could never seem to bring his ability to bear on the most important occasions. He would defeat several of the top tennis players at Forest Hills. But when his turn came to play Bobby Riggs in the semifinals or finals, his game would be miserable. He'd miss a lot of balls, and lose by a lopsided score.

His sense of humor could be quite admirable, though. I remember watching him once play Nick Carter on a very hot day in Sacramento, California. Now, Nick was a good player but not at all in Kovac's league. Frank ran him back and forth unmercifully. At one point, Carter was sweating to beat the band. Kovacs was careful not to run Nick so hard that he couldn't get to the ball. So Carter got all those balls, but his tongue was hanging out, and he was so beaten down he just dumped the ball over the net and waited for the inevitable. An easy sitter, that Kovacs could easily have put away. Instead, Kovacs loped up to the ball, ready to hit it—there was Carter leaning on his racket, waiting forlornly—and Kovacs said, mockingly, "I just can't do it!" He let the ball drop and Carter got the point. But from then on, Nick was a beaten man.

**Jack Kramer** A fine player with a consistent attacking game. He paved the way with forcing ground strokes and superb approach shots. He had a strong serve, which would often force weak returns

from his opponent. When he wanted to put on the pressure, he could serve an ace or two followed by heavy serves to keep the pressure on. He could take shots early and cradle them on either the backhand or forehand sides, so that it seemed he almost got to the net ahead of his approach shots. This was a consistent winning tactic for him.

Jack was not a tricky volleyer, but an excellent one who always played the volley soundly. This gave him a winning percentage. It was like playing the slots for the house at Las Vegas. If the percentage was in your favor, you wouldn't win every single time but you'd win a lot in the long run. That is what is called "percentage tennis."

Jack also had the benefit of the best practice in the world because he lived in Southern California where most of the top players of the day were. For example, I asked him if he had played Tilden often as a boy, and he said "Yes, about once a week." We youths in Northern California didn't have nearly as much of the top class competition and learning. Tilden won the national Championships some seven times and was very good about playing with the younger players. I cannot imagine that if Kramer asked Tilden for advice Tilden wouldn't give it to him.

Kramer had bad luck in the first Wimbledon he played. He had developed bad blisters on his right hand, and lost to Drobny in a close match.

As with Parker, Riggs, and Budge, Jack won the National Junior Championships before winning practically everything there was as an adult.

**Fred Kovaleski** A good player, an outstanding collegian; and in his post-college days he made the ranks of the first ten. He was an especially fine doubles player then, as he is now in senior competition. In an earlier life, Fred was an undercover agent for the CIA. His cover? Being a touring tennis player!

For eight or ten years, Fred managed the Nabisco Dinah Shore tennis event, which was put on as an adjunct to the women's golf tournament Dinah hosted. Fred brought in top players from all over

the world and set up pro-am teaching and exhibition events. He was a very good organizer, and worked hand in glove with Dinah, who recruited fantastic entertainers for us.

**Billy Johnston** Alas, he was before my time, and I wouldn't have been good enough to ask him to play, anyway. (I was only eleven when I took up tennis, and wasn't any match for any of the experienced players until I was seventeen or eighteen.)

Billy had a superb forehand with a western style grip, which was very suitable for clobbering high bouncing balls, the kind they were making in the 1920s.

Billy was one of the truly great players in the early days of Golden Gate Park, along with Maurice McLoughlin, Helen Wills Moody, and others. In truth, Billy did not go to the park often, because he preferred playing at The Olympic Club.

No wonder. The tennis clubhouse at the park was just a shack. There came a time when it had fallen into terrible shape. A three-toed rat used to hang around the men's shower room, up in the rafters, and he'd race back and forth, scaring everyone. Well, one day "Old Three Toes" fell down onto the floor, and the players dispatched him.

We got a committee together to raise funds for a new clubhouse, and I went before the San Francisco Board of Supervisors to get approval to build it. We got it done, with no opposition at all, and the new clubhouse was named in honor of Billy Johnston. Or, the William M. Johnston Memorial Clubhouse, to be more formal.

**Henry Kamakana** From Hawaii, he came to the mainland to go to school and became one of the top ten players in Northern California. I never knew him as a junior player. He was a few years younger than I. (Nearly everyone is, I find.) Henry is very congenial, a good guy, worked hard and won some major matches. He turned pro pretty early in the game, and is manager now at a private tennis club on the San Francisco Peninsula which hosts an annual tournament every summer for seniors, that all of us over the age of thirty-five love to play in.

**Rod Laver** He came on after my era, and was one of the outstanding players. He was not of great height but he was exceptionally strong. He had good eye and hand coordination and won all of the Grand Slam tournaments for several years against the best competition the world could offer. He had a terrific backhand which he could send in any direction. He was particularly notable for passing down the line with only an inch, or three quarters of an inch, to spare. Rod did everything well—ground strokes, volleying, serving. He had strength, stamina, and speed. He was left-handed and very fast in covering the court.

**Barry MacKay** We called him "Barry the Bear." He was a top player with strong arms and quick hands, and he had a very fine serve. He was an excellent volleyer. He was bigger, heavier, slower, and stronger than most of the guys. His timing was superb. He was always good-natured and worked hard.

He is very good as a radio and TV commentator. He understands the game, and for quite a few years managed the pro circuit that went through Northern California.

I was present the day he met his wife. Along with a few other players, we'd been guests of Merv Griffin on a TV shoot in Monte Carlo. Boarding our flight home to California, we were both entranced by the charming hostess. It was love at first sight for Barry. They've been together ever since.

**Art Larsen** When it came to moving, Art was one of the fastest in the game. He was national champion one year, beating Herb Flam in an exciting five-set match in the finals of the U.S. Singles at Forest Hills.

He did have vagaries—Art would chase anything in skirts. He would do some foolish things—like make a play for the daughter of the tournament director, which was deleterious to the reputation of the rest of us.

**Enrique Morea** A quiet, good-natured, handsome Argentinean. Son of the landed class and the top tennis player of his country. I played bridge with him nearly every night one summer when we

were playing the Eastern circuit. He was very literate, had a perfect Spanish accent, and also spoke French fluently. Upper-class Argentinean families of that day sent their children to England or the U.S. for schooling, so his English, too, was impeccable.

Right after I finished law school, I had an opportunity to fly down to Argentina and play a couple of tournaments there. Accept I did, with three companions—all female—Nancy Chaffee, Barbara Scofield, and Nancy's mother. I served as frequent escort of either or both girls. I played mixed doubles with Nancy, and we lost to Barbara and Enrique. We also played mixed in Peru and Brazil. It was great.

**Don McNeill** A fine gentleman, the U.S. national champion in the early 1940s. I served as a linesman for a match he played with Bobby Riggs in Oneida, Wisconsin. For three or four hours (it was a five-setter), I watched and admired his demeanor. Not easy to keep your cool against Bobby!

**Tony Mottram** A very good-natured English player. Derek Barton, whom Bob Falkenburg used to call "Derelict," was also of that era. They were numbers one and two in Britain in my day. Australia and the U.S. were the two top tennis powers then. At one time, in the 1920s, the French were the dominant players. And then the English. Tony had a good deal of ability, but never had the experience of playing against strong players like those the Australians and Americans had.

**Gene Mako** A very sharp guy. Reached the finals at Forest Hills one year against Don Budge. For several years Budge and he dominated the doubles tennis game. At the same time, they were also numbers one and two in singles.

Mako was from Southern California. He recalled to me that Bill Tilden was very accommodating as a top player, and that, as a junior, Mako would summon up bravado and ask Tilden to play with him. More than likely, Tilden would be playing cards at the time. "Well, hang around, kid," he'd say, "and after we finish a couple of rubbers that would be fine."

Mako was Hungarian, and spoke that language fluently. Before World War II, he and Budge were playing a match in Budapest against the top two Hungarian players, and during a changeover Mako overheard the Hungarians saying to each other (in Hungarian), "Now we're going to knock the hell out of these Americans." Mako responded in Hungarian, "The hell you are! You just wait and see!" The Hungarians were so shook up and surprised at their American opponent knowing their language that they served a few double faults and lost their concentration and the match.

Mako had a variety of abilities. He was artistic, and in later life opened an art gallery. He was a top bridge player in national tournaments. Gene was a pretty good actor, too. He had a one-line role in "Strangers on a Train," the movie they used me for as the hero player in the tennis tournament segment of the film. "Are you playing next?" I believe, was his line.

Some time later, Gene went into the manufacture of tennis courts. When the California Tennis Club, of which I was a member, had a problem with their courts—they slanted toward the center where the drain was—we called in Mako. The server at that time had quite an advantage because the ground from which he served was two or three inches above the rest of the court. I wondered, if we changed the drainage system so that the court would be level all the way around, if that would solve our problem. Perhaps resurface an inch or two every year or so, and at each resurfacing, the court would become more level. I asked Mako if that would be possible.

"As a matter of fact, it would be," Mako answered. "In about ten to fifteen years, you would have level courts. But," he added, "that's a lot of trouble." And then he paused for a moment, looked at me, and opined, "Would the players know the difference?" I had to shake my head at that, and we dropped the attempt.

**Eddie Moylan** For various years, he was in the top ten in the U.S. An Irish boy, he had a twinkle in his eye and a smile which all the girls liked. Somehow he didn't capitalize on his attractiveness to

women, but he was always good-natured and had a neat way of looking at things. We palled around and were roommates from time to time.

Once, Eddie and I arrived at the same time to check in for the National Singles at the West Side Tennis Club in Forest Hills. We paid our tournament fee, and Eddie turned to me. In his usual genial way, he said, "Isn't this something? They allow us to pay entry fees to help fill their stadium!" We didn't get as much as a free Coke or free lunch in those days. We had to pay for everything. There was no prize money. Winners would get a cheap medal or something like that. We had to play those Eastern tournaments, or we couldn't get ranked by the U.S.T.A.

Later, when my eldest daughter was doing her internship for veterinary practice at Cornell, Eddie was very helpful in introducing her around and getting her tennis games. For twenty-two years, he was the coach of the Cornell Tennis Team.

**Gardnar Mulloy** A fine player from Miami, Florida, who's been active in tennis for as long as I can remember, particularly since he is nine years older than I. I first played him when I was twenty, in my first nationals. He beat me, but I took him to five sets in the round of sixteen.

Gardnar has played in the top rungs of American tennis, seemingly, forever. For seven years or so, he was national doubles champion with Billy Talbert. Throughout his life, Gardnar's been known for being a hard competitor, and for not giving up or saying die. For years he was not on friendly terms with the United States Tennis Association, but then made up with them after they appointed him captain of their age eighty international seniors team with his very own cup for the grand prize.

At one of our veteran tournaments, Gar and I had a little chat about the problems of growing older while still trying to remain tennis-competitive. I'd watched him play someone who hit shots straight down the middle at him. Mulloy would hit a nice direct return, and the shot after that would go wide to his forehand or back-

hand. I could hear Gardnar's feet go clump-clump-clump, trying to rush to get to the ball.

"It's not quite like it was in the old days," said I, "when we knew where the ball was going and would be there in the right place waiting for it."

"Yeah," Mulloy replied. "That's the way it is, now. It takes me a while before it registers which way the ball is going, and that's when my feet make a lot of noise—trying to make up for lost time."

I can empathize with that now, and I almost could then.

**Alex Olmedo** We called him "the chief." He came from Peru. He was very good-natured, had a nice smile, and was about as dark as the ace of spades. I remember Pancho Segura calling over to him once at an outdoor photo session at one of our tournaments, "Get out of the shadows, Alex. They won't see ya!" Coming from any of us palefaces, that might have sounded racist, but from Pancho to Alex, no problem.

I knew him pretty well and liked him, and so did my mother, who loved to cook for him whenever he was in San Francisco. He was a beautiful looking human being. He was built not heavily, but strongly, and he moved just like a great big graceful jungle cat.

**Frank Parker** As I've said earlier in this book, Frank was one of my early heroes in tennis. Long after the sound and fury of my own career had faded, as had his, we played together in the Grand Masters. We shared a house at a tournament in Lakeway, Texas, where Cliff Drysdale was the pro. I brought my son, Mark, and daughter, Sue, with me on that trip. The four of us were like family.

Looking back, Frank was my stepping stone to becoming well known in the early days. He was the defending champion of the U.S. when I, an unknown out of the West, played him in the quarterfinals at Forest Hills in 1946. I was playing very well, he wasn't, and I beat him in five sets, the last at 6–1. It was getting dark, and he was wearing dark glasses, having trouble with his eyes. Winning against him put me among the top ten players, just like that.

**Fred Perry** I met Fred when we were both part of the attraction at

Vic Seixas' "Tennis Fantasy" week. He was very courtly—he won Wimbledon three times in a row. He had a highly successful clothing business. On our Tennis Grand Masters tour, we were invited by Perry to outfit ourselves with sweaters, shirts, one of everything, all very handsome, all with the Fred Perry logo, of course. We wore his clothing all over the world, so it was pretty good advertising for him.

**Yvon Petra** A lovable giant of a man. After my being ahead two sets to love at the semifinals at Wimbledon in '46, I lost to him, feeling like Mutt to his Jeff. But I defeated him in the semis the following year, which got me into the finals against Jack Kramer. Yvon was then the reigning Wimbledon champion, so my win over him reaped a lot of press.

Actually, I think I could have beaten him the year before, also. I had forgotten a classic lesson learned long ago from Jimmy Kirker when we were boys at Golden Gate Park. We'd been discussing how to behave in a match. "When you are ahead, you must try twice as hard," Jimmy (who was two or three years older than I) proclaimed. "Because that's when the other fellow is going to be trying twice as hard to win, and if you don't bear down, he's going to pass you and do it. " He was right. That's what happened in my first match with Petra.

Yvon was a magnificent volleyer. He didn't speak much English, but he had quite a good sense of humor. (He had to, to have survived several years during World War II in a prisoner of war camp.) Some years later, he was a spectator, as was I, at Wimbledon and strode over to me to say hello and introduce his granddaughter. He was very gracious; we gave each other the obligatory kiss on both cheeks.

## 13. Here We Go Again

CONTINUING MY "names" trip down memory lane:

**Budge Patty** John Edward Patty was his whole name, but he was always, within my memory anyway, called "Budge," after J. Donald Budge, for his reddish hair.

You know, it's funny. When he first arrived in Europe, he fast developed a dislike of the French. But he liked the French girls—how could he help that?—and before long he was fluent in their language, and liking Europe and its way of life more and more. In time, he married a Swiss girl and settled down.

Years later, when I was invited over to play in Monte Carlo, I ran into him—at least I was pretty sure it was him—at a restaurant on the wharf in Villefranche.

As is my custom when deciding in a strange town where to go for dinner, my date and I strolled the length of the wharf, studied the menu posted in the window of each of the five restaurants, the prices, the offerings, and then opened the door to get an idea of the ambiance inside. We both agreed on which seemed like the best choice.

We went in and sat down, were enjoying a glass of wine, when, about ten minutes later, another couple entered. The woman was very chic; the man, very dapper, quite tall, broad shouldered, beautifully dressed, hair combed and just-so in place. He looked distinctly familiar, but it had been so many years I wasn't sure. They sat down and studied the menu. Could it be my old friend, Budge? What would he be doing in Monte Carlo? I'd heard he'd gotten married and had a family. But I didn't know if he still played tennis. Well, I

couldn't just walk over and say hello without being sure. I wasn't going to take a chance on being dressed down by a Frenchman for being wrong.

And then I remembered a certain mannerism Patty used to have. I said to my date, who was facing in his direction, "Just keep an eye on him, don't stare, but if he starts to do this"—I patted the back of my head where a couple of strands of hair stood up instead of lying flat—"let me know." And about five minutes later, she said to me, "He did it! He did it!" So I immediately got up and went over, and said "Monsieur Patty!" He looked up and smiled. "How ya doing, Tom!" just like in the old days. "What are you doing here?" Turned out we were both there for the same tournament.

**Russell Kingman** On my first trip to Wimbledon in 1946, the U.S.T.A. sent a sort of chaperone along to take care of our little details. This was Russell Kingman. He was fluent in French, though he spoke it with a New York accent. He was a world-class cellist, and a very agreeable companion.

**Dinny Pails** An agreeable Aussie with a big Aussie accent. He had very good ground strokes. He was not vigorously aggressive like Jack Bromwich. I would like to have known Dinny better, but our teams did not fraternize. We were off in our own encampments.

**Pierre Pelizza** He was one of the top two French players after World War II, he and Yvon Petra. His brother, Henri, became a pro in the United States. Pierre was my opponent when I played the mixed doubles at Wimbledon with Louise Brough. It was the round of sixteen (the quarterfinals), and we won, although it was a very close match. Pierre and partner held point-match against us once, on Louise's serve. I remember it well. Louise was serving. Her first serve went out. Her second was her usual hop, a spin over which she had good control. We won that point and it was deuce, and she went on to win her serve. Then we went to the finals, and won that against Geoff Brown and Dodo Bundy.

**Adrian Quist** "Quistie" was his nickname. He was friendly, an excellent doubles player; in fact he won every major doubles title in the

world. It was he and Bromwich who lost the deciding match against Kramer and Schroeder for the Davis Cup those many years ago.

**Mervyn Rose** He was a left-hander who hit the ball very hard and quick. I played him in the semifinals of the Sugar Bowl Championship in New Orleans, beat him in five sets and retired the cup. He was then the number three or four player in Australia.

**Bobby Riggs** Now, there is a memorable fellow. He was very good at anticipating the ball. He had a brain like a computer that would tell him where the other fellow was going to hit the ball. And that's where he would be, early. He could hit the ball from all over the court, and different kinds of shots depending on conditions and his opponent. He could hit balls flat, with topspin or slice, high or low, or any combination of same, which would give his opponents fits. And if there were any shots that his opponents could not handle, that's what they were sure to get. He always knew which balls he should take, and when he was playing doubles he knew which balls to leave to his partner.

I was his partner in a number of doubles matches toward the end of his career. In the National 65 doubles, he had things figured out very well. "Now, Tom," he said, "I'm slowing down a bit. You're the faster player, but if they hit it right where I am, I can hit a volley as well as anyone. So let's arrange things so I handle a smaller portion of the court. You handle three quarters, and I'll handle one quarter, and if that's all I have to handle I can cover everything within that radius very easily, so wherever I am they're hitting it right to me. If I don't have to move for it, I have better strokes, I'm a better player than they, and our technique should work out just fine."

And it did. We were well on the way to winning all four of the National Doubles Championships—it was my first year in the 65s. We won the first three titles rather easily, and I think might well have won the fourth if the U.S.T.A. hadn't changed the dates of the tournament after he had already made a commitment to play somewhere else.

Bobby liked to exaggerate and camouflage stories. I remember one time at a Grand Masters event when we were all in a taxi going

to some formal tennis affair. Fred Perry had been invited specially to act as the chief umpire. Pancho Segura was also in the car. Perry, Riggs, and Segura were all older hands than I. Riggs said something to Segura that was a little fanciful. Segura doubted some portion of the story, to which Bobby replied, quite literally to my recollection, "You know I wouldn't shit you, Pancho." With that, the whole car broke into laughter because we all knew perfectly well that he would.

If you're ever in the San Diego area, pull off the freeway at Encinitas, cruise up Santa Fe Drive, and find the Bobby Riggs Tennis Museum. It's a labor of love, full of memorabilia gathered by a lifelong friend of Bobby's, Lornie Kuhle. There's the first cup Bobby ever won (the Southern California Junior Tennis Championships in 1930, when he was thirteen); lots of magazine covers featuring him; clippings of Billie Jean King's "War of the Sexes" classic defeat of him; an internationally syndicated Peanuts cartoon featuring him.

A lovable rogue was Bobby. He sure put his imprint on tennis. Did you know that he won the Wimbledon singles, doubles, and mixed doubles (in 1939), and accomplished the same three wins in the U.S. the following year?

**Vinnie Rurac** I can't remember whether I met him on the Eastern circuit, or in Europe. But I always liked this effervescent Romanian. About thirty years later, I had cause to test the comradeship that carries on in tennis. I was looking for a place to stay in Bucharest, to take a little vacation after Wimbledon. I thought of Vinnie, but didn't know where he was living; my sources thought he was "somewhere in Southern California." Someone else suggested Ojai, so I called the best club there to ask if he was on their staff as tennis pro or assistant pro. Sure enough, they knew of him. "He's at such and such a club just down the road. Here's his number," I was told.

So I called him. "This is Tom Brown, Vinnie. Do you remember me?" "Well, I sure do," he said. "I lost to you twice. What can I do for you?"

I told him my problem. "I've got just the place for you," he said.

"In English it translates to 'My Uncle's Inn'." He spelled out the Romanian name and described it as "a neat little place, from the sixteenth century, great big wooden doors that swing open, and a little carriage run where an orchestra used to play. It's just delightful. The food won't be too good; they don't have much in the way of food there, but the rooms and the atmosphere are great." And sure enough it was. I called Romania long distance to make the reservation. They didn't speak any English, but we hit on an understanding in French.

More recently, I visited Vinnie at his home near Santa Barbara, California. We yakked for quite a while, and I learned to my surprise that it was he who invented the yellow optic tennis ball so prevalent in tennis now. (In fact, is there any other kind?)

For years, he told me, he led tennis pleasure trips around the world, and as a way of calling attention to the complimentary balls he provided (courtesy of the Wilson people), he hit upon the idea of coloring them. He dyed them himself in his bathtub at home. Sadly, he never took out a patent on his great idea, so instead of being very wealthy today, he isn't. But I would venture to say Vinnie is a happy man.

**Whitney Reed** Any stories I could tell about Whitney would be beggared by the number of stories out there about him. I lost to him once in the finals of an Invitational tournament at Pebble Beach, California. The match was scheduled for two o'clock. We were sitting around, waiting for Whitney to appear. No Whitney. A modern crowd would have demanded a default, but I wasn't about to do that to my old buddy, so we waited, and waited some more. Fifteen, twenty, thirty minutes. No Whitney.

Finally, about forty-five minutes after the match should have started, he came strolling along a sandy path to the courts, carrying his tennis shoes. He'd been walking on the beach. So he took his sandy feet and put them into his sandy shoes, and we started to play. And he played very well, astounding me and defeating me. He hadn't even had anything to drink, which was unusual for Whitney.

Sometime after that, I was going to Wimbledon and taking my son, Mark, and needed an extra ticket to watch the finals from the players' box.

"What the heck," said Whitney. "Take mine." He was a really nice guy.

Whitney had an astonishing touch with his racket hand. He would rather make an unorthodox shot than the expected one. He reached the finals of the U.S. Championships one year against Frank Sedgman, who won rather handily. But that was quite an achievement for Whitney, to beat a number of good players to get to the finals. He was ranked number one in the United States that year.

He was a true sportsman. He would never take advantage of anybody. He would even call a ball against himself. The only thing was—he liked booze once in a while, and would think nothing of downing one, two, or four drinks before a match. And then go out on the court and play very good tennis, and return some of the best serves in the game. Go figure!

**Dennis Ralston** I did not know him well, but he was the top player in the U.S. in 1956. I remember that, because that was the year my father died. I had a commitment to play in a tournament about three weeks after my dad's death, and I kept it. My tennis got better as I went along. I defeated Jack Frost and Whitney Reed, and had a hard three-set match against Dennis.

It was nip and tuck until about 4–all in the third set. My passing shots were working well and I would occasionally break his serve. He would come in closer and closer, hanging his nose over the net to intercept the passing shots. Finally, on his serve, he came in and I looped the ball up and over his head twice in a row. He lost the game, the next serve was mine, and I won the match. So that's my best memory of Dennis.

**Ham Richardson** He was a year or two younger than I. He had a very good attack game, and served well. I remember playing him in a match in Salt Lake City. It went three sets. I squeaked by, and got into the finals the next day where I lost to Tony Trabert.

**Dick Savitt** A very strong player with great ground strokes and a fine serve. He was a so-so volleyer. But he won Wimbledon by sweeping players off the court with his ground strokes. He was unique among us, for he was working most of the time when he was competing. He was a trouble shooter and point man for an oil mogul. Later he went into the brokerage business.

His New York accent was potent. I knew him in his early days when he was one of the hackers—a player who's a necessary part of a major tournament to fill in a draw so that the top players—the big attraction—are not eliminated too early. As time went on, he suddenly blossomed and became a top player and went through Wimbledon winning every match in straight sets.

Even after he stopped playing seriously, he kept up his tennis contacts. He established a special 800 number that he'd give you, if he liked you, with the invitation to call him anytime. And you never knew when he might call you, just to chat. Dick always called me "Brownie" in a sort of growl.

**Vic Seixas** E. Victor, we called him. The "E" stood for Elias; no wonder he dropped it. I've known him since I was twenty-one, when we played together on the Eastern circuit. He has always been very good humored, a bit on the quiet side, friendly, and a fair and honest opponent. His ground strokes weren't so good but they were better than they looked. And he had a fine serve and volley game and a sort of semi-western forehand that he would hit with a lot of topspin.

He won our national championship several times, and Wimbledon also. He was one of the mainstays of our Davis Cup team, along with Tony Trabert. They went down to Australia and lost the Cup once or twice, but won it back another couple of times. Vic captained the Davis Cup team three times, and played on it seven years.

**Ted Schroeder** He was kind of friendly with me, but made himself obnoxious with the other players on our postwar Davis Cup quest to Australia. He insisted on doing everything his way. He ran our appointed car into a truck and another time into a parked car. So the boys sat him down and said, "Now Ted, you're not going to drive

anymore. Tom's not playing (because I was recovering from the flu), so he's going to be the driver."

And Ted was very tight. We all agreed that when Christmas came along, we should each buy a mandatory present—not to exceed one pound—for the other guys. Schroeder peeled a pound note out of his wallet and tossed it over. "Now Ted, that's not the way it works. You've got to buy a present."

He wasn't as bad as he seemed—it was just his mannerisms that were annoying. On court, he was a hell of a player. Never gave up. Attacked with fury. That Davis Cup opening win of his over Jack Bromwich in '46 was a white-knuckler all the way.

Much later, Ted had an injury playing golf, which knocked him out of both golf and tennis. His son, however, became a U.S. Amateur golf champion and went on to a successful professional golf career.

**Ken Rosewall** He was known as "Muscles." He wasn't very tall, only about five-eight or -nine, but he had just about the strongest arms of any machine in the game of tennis. His legs were very strong, too. He had splendid reflexes. The ball would be coming somewhere to the left or right of him, at an odd angle, and you could see him assessing the situation, knowing by instinct where it was going to land, and with what speed and with what direction. And at the right moment, his legs began to churn. They just churned like the fastest steamboat you ever saw. And they carried him over to just the right distance, at which time they reversed and at about the time that the ball was about to land everything was in position, the muscles were flexed, the racket was back, and all he had to do was let the arm come forward and the shot would be made perfectly. Because it was all arranged in advance. And then the legs would churn again, and he'd be off to the other side of the court to wait for the next ball.

Ken moved as well, or better, than any player ever did. It would seem that the shot he was making was the easiest shot in the world because he just let the arm follow through. It was so simple, graceful, and easy that it almost looked as if he weren't trying.

**Len Saputo** A very enthusiastic player and an advocate of frequency of play being a way to stay healthy. Although there are eighteen years between us, we struck it off as friends when we came up against each other in a National 35s event. (I was fifty at the time.) Len's a doctor who specializes in alternative medicine, and for thirty years I was one of his patients.

Early on, at one of our office visits, he asked me how often I played tennis. "Two or three times a week," I told him. "That's not enough," he chided. "You must play more, or you'll die." He was being facetious, of course, but it goaded me into getting out more often.

**Bob Sherman** A fine competitor with an unorthodox style of play. A quiet man, good-natured, he's his own person. He walks on court in a meandering style, but sure as hell knows where he's going.

One time, when I was playing in Southern California, a U.S.T.A. referee scolded Sherman for not hurrying to towel off. "Mr. Sherman, you're taking too much time." Sherman muttered something under his breath, and the referee hollered "Fine! Half a point penalty for using a curse word!" Sherman hollered across the net to me, "What did I say, Tom?" I couldn't resist. "You said a bad word," I shouted back. "You said U.S.T.A." Everybody laughed, except the official, who didn't get it.

**Mahinder Singh** We met as seniors at a tennis tournament in Hungary and teamed together compatibly in doubles. I introduced him to ice cream bars. He had never had one before. We hit it off so well he invited me to travel to India and be his house guest. He had a cousin who owned a tiger refuge, and I would be a guest there also.

What a wonderful trip that was! Did it with Barbara Scofield Davidson and her traveling companion. We stayed at the tiger refuge a week, venturing out every day on the back of an elephant to view the wildlife. No tennis that trip, but who cared!

**King Van Nostrand** We played the same tournament in São Paulo, Brazil once, and have met casually at tournaments in California. I don't know him well; we're not in the same age group. But he was

very helpful to me when word got around about my knee problem. He has had both of his knees replaced. He'd been advised not to play tennis again, but he had to give it a shot and has done very well with those new knees.

"My knees might quit on me tomorrow," King told me, "but I would never regret a thing for the nine years of enjoyment (as of this writing) they have given me.

"Since I had them done, I've had only four on-court losses (including two injury defaults), winning sixty-one of sixty-seven singles tournaments. I feel it is important for doubters to see that having a prosthesis (or two) does not necessarily have to slow one down or relegate them to the sidelines."

"King," by the way, is not an affectation. His real name is Kingman.

# *Tie Breaker*

# 14. The Ladies, Bless 'em

CERTAIN WOMEN, both on and off the court, have played a major role in my life. Here goes with some more reminiscences.

**Louise Brough** A very talented singles and doubles player. I was about fifteen when I first met her on the junior circuit in the Northwest. But I didn't have occasion to say more than "Hello" until I was twenty-three and planning to go to Wimbledon. I wanted to enter the mixed doubles and heard that she did not have a regular partner (as her chum, Margaret Osborne, did with Billy Talbert).

So I asked her if she'd be interested, and she was, and we won it! And we also won the U.S. Mixed Doubles in 1948. (She didn't throw me over in 1947. I was heavily involved with my law studies that year, and could not commit myself early for the big tournaments. She teamed with John Bromwich in mixed doubles that year, and they won. What a gal!)

**Margaret Osborne duPont** I knew Margaret and her mother early on because they would come out to Golden Gate Park and to the Cal Club to watch us play. At twenty-three, she was already the U.S. national women's champion, a member of the California Tennis Club, and always in search of fresh talent to play with.

Actually, I had played some with her when I was just a kid in 1938, in those brooding days before America got involved in World War II. We played several exhibitions at military bases around San Francisco. Big crowds of soldiers would always show up. After all, what else did they have to do before war was officially declared?

Another remembrance of Margaret: she and Louise were guests of Willie duPont several summers at his estate near Wilmington,

Delaware. Several men players, myself included, were also invited. (This was before Margaret married him.) I used to get up very early in the morning and go running with Eddie Moylan around Willie's horse racing track. Imagine our surprise at six a.m. one morning when there, at the rail, stood Willie with his stopwatch, timing—not his horses, but us!

Another time, in New York, a group of us, including Margaret, were invited to a gala dinner at the Waldorf-Astoria hosted by Willie. Alice Marble sang the opening number—she was then a torch singer in a night club. It was my pleasure that night to escort another San Franciscan, lovely Barbara Scofield. Although I would have traveled by subway that evening if I'd been on my own, I knew I couldn't ask Barbara to go that way. So we went by cab, and I got to say to the driver something I'd been wanting to say ever since a childhood dream: "The Waldorf, please."

**Pauline Betz** A fine and determined warrior on the court, very consistent off the ground and she covered court better than any woman of her day. She was, in fact, the outstanding woman player in the world, champion of both Forest Hills and Wimbledon. She was very agreeable and easy to get along with.

She did have a serious memory defect once. When she flew to London one year to play at Wimbledon, she forgot to retrieve her tennis rackets from the overhead rack. They went on to Sweden without her. She got them back in time for her match, however.

**Pat Canning Todd** One of the top five women players when I was young. She was rather naive. I remember once in Paris her sashaying down the Champs Elysées swinging her purse the way hookers do. "Pat, don't do that unless you want to catch a man to be a paying customer," we entreated her. She didn't understand.

Her brother, Bill Canning, was a very nice fellow and a good player. I came up against him once in the finals of the California State Championships.

Pat married Dick Todd, who didn't know much about tennis but coached her a fair amount. She had good ground strokes and a

strong backhand. I saw her a few years ago at a tournament in San Diego. She has white hair, now, but I would have known her anywhere. She looked great.

**Doris Hart** I never knew her well because she grew up and played all her tennis in Florida. She was on the Wightman Cup team with Margaret, Louise, and others. I always had the greatest respect for her overcoming an extreme limp handicap because of having had polio as a child. Yet she became one of the quickest women players in the game.

**Ann Kiyomura** I did not know her when she was young and won the Wimbledon women's doubles in 1975. But in my senior years I enjoyed practice hitting with her at the Peninsula Tennis Club in Burlingame, California, where we were both members. She is Mrs. David Hayashi now and mother of two grown children. I have found her to have an exceptionally strong game and can readily understand how she could have been a top world player.

**Billie Jean King** Never knew her well, only casually to speak to. When she was having her peak at tennis, I was at work in a law office, or busy being a father. I took my daughter, Sue, to some tournament venue once. Sue has a lot of chutzpah. In our hotel room, she asked me if I had some thread to sew on a button. I said no and didn't think anything more about it. Next thing I knew Sue was back in the room, with needle and thread in hand. "Where'd you get that?" I asked. "From a nice lady down the hall," said Sue. "And," she added, "she knows you." "What's her name?" I asked. "Billie Jean King."—Oh.

About that famous match Billie Jean played against Bobby Riggs—and won—I never got in on the betting, but I feel pretty sure Bobby threw it.

**Barbara Benigni** I've known her from her young competitive days when she was a dedicated girl with high ambitions to be a top player. But her father tried to direct her career, and eventually she became discouraged and dropped out of competition shortly after winning the National Junior Singles champion title for girls eighteen and under.

In later life, I practiced frequently with her at the California

Tennis Club. Everybody calls her "Coach" because she is very helpful at taking over as a trainer to whoever asks for help with their tennis.

**Barbara Scofield Davidson** I first met her when she was a school-girl in San Francisco. She had entered a tournament and came dashing into the Cal Club to play her first match, burdened with a bag of schoolbooks over one shoulder and her tennis racket over the other.

"Your match has been postponed until tomorrow," a person at the tournament desk told her. Barbara had especially gotten leave from school so she could play that afternoon and now, after going to all that trouble, the tournament was telling her "We've rescheduled you" without even telling her in advance. She let out a word that I didn't know little girls knew and slammed her books on the ground.

In later years I have gotten to know her really well when I discovered that she, too, had a passion for travel. She and I, and her husband or friend, have taken several long pleasure trips together, the most memorable being to India. It was also thanks to Barbara that I traveled to Egypt, my favorite non-tennis trip of all time.

When Barbara and I were young, we shared a wonderful experience—a tennis trip to Argentina. They wanted a couple of first ten international players for their men's and women's divisions. Those requirements were met by Barbara and me, because the really top players of that day were through with their year's tennis and not interested in a long trip to Argentina where they wouldn't be offered large sums of money. But we grabbed at the opportunity because we both wanted to go there. And they were picking up all the expenses, so that was also attractive.

Barbara's interest went deeper than mine, because she accepted a post from the American Minister to Argentina to be his social secretary for a year. She was in her low twenties then, and had a ball.

Barbara and I have kept up with each other through the years. Whenever she's in San Francisco, we try to get together for dinner. Our India trip was remarkable. We were entertained by a maharajah who, later on, came to Florida as Barbara's house guest. I served as his guide at Disney World.

Barbara was a top ten player in the U.S. and a last eight player at Wimbledon and has privileges to this day for seats to all four of the Grand Slam events, as do I.

**Althea Gibson** My memory of her is of a tall black woman standing on the platform, all alone and looking lonely, at Knightsbridge Station in London, the transfer point for Wimbledon. That was the year she won it. She was a fine player, very angular and long. Could get to a lot of balls and had a lot of power.

**Alice Marble** Very attractive and stylish player with beautiful strokes. She had an innovation in the game—she was very good at the net and ran in much more often than other women of her time. I played with her as a junior and I figured that even though I felt she didn't try very hard that made me the women's champion of the U.S. when I took a set from her. Alice was from San Francisco, and, like me, played her tennis at Golden Gate Park. She was a couple of years older. Her brother was a baseball player for the Seals team. There is a playground with tennis courts in San Francisco named for her. I wouldn't mind having such an honor one day.

**Barbara Krase** A good junior and women's player, who was on the Eastern circuit several years that I was. In New York, once, I asked her if she'd like to see a musical with me. She did. It was a nice evening. I took her home, and that was about the size of it.

Barbara married early and settled in Boise, Idaho, where she and her husband started an indoor tennis club. Many years later I went there and won a national indoor tournament, in fact two of them— for players in their seventies and seventy-fives. She greeted me cordially and we had a good time recalling the old days. She, too, used to live in San Francisco, across from Taraval Park, where she learned her tennis.

**Virginia Kovacs** When she was Virginia Wolfenden, she lived right around the corner from me, in San Francisco. She was four years older than I, the same age as Margaret Osborne. There were three sisters—Virginia was California state champion, and her younger sister Nancy was a pretty fair tennis player, but not as good as Virginia.

The third sister I know nothing about. Virginia went East, got a national ranking, returned to California and married Frank Kovacs. Their marriage didn't hold, but they did have a son.

**Kay Stammers Menzies** A top English player in my day, and a very pretty girl; the press loved her because she was so photogenic.

**Dodo Bundy Cheney** Dodo (short for Dorothy) was three or four years older than I, already a well-known player the first year I went to Wimbledon. She was on the Wightman Cup team that traveled on the same ship as I. There were six girls, and they hung together, didn't mix; nor did we males. We all had tunnel vision. Gotta think about the game!

Dodo was always amiable. Later on, she married a Pan Am pilot.

Her highest national ranking was, I believe, number four. But she's won something like 350 national tournaments. She is quite amazing.

Dodo had a fantasy. The U.S.T.A. gives little gold balls to winners of singles Championships, and silver balls to the finalists. These are dinky little trophies. If you're not careful, and turn the ball too roughly the gold gilt may come off on your hand. They are not solid silver or gold! I have not kept my gold balls. I gave one once to my girlfriend. She was annoyed with me at the time and threw it out the window. Neither of us ever looked for it.

Dodo got it in her head that she wanted to win an even hundred gold balls. She far outdid herself. She has won the largest collection of gold balls of any tennis player anywhere.

Her father and mine were lifelong friends. It took me thirty years to discover that I had this bond in common with her. Dad used to talk about the old days in Santa Monica, and tennis games with his neighbor, Tom Bundy. The young men were about the same caliber—not very good. (Or so I assumed. I didn't pay close attention to my dad's stories.) I thought Tom Bundy was just a namesake for the famous Bundy family. I knew about Dodo, she being of my generation. I knew about her mother, May Sutton Bundy, who was a tennis champion in the 1890s. But it never occurred to me that my father's

friend, Tom, could be of the same family because dad was such a lousy player.

On a goodwill trip to Osaka, Japan, on a sightseeing bus from one castle to another, Dodo and I happened to sit next to each other. "This is ridiculous," I said to myself. The Tom Bundy my father had played with could not be any relationship to her. *Or could he?* So I asked her pointblank. "Was this Tom Bundy my father used to play with any relation of yours?" Her reply was quick. "Yes," she smiled. He was my father." I was amazed; I had never suspected.

To my chagrin, I belatedly realized that her father, Tom, made a big mark in tennis. He played Davis Cup, and as Maurice McLoughlin's favorite doubles partner, they won the U.S. Doubles Championships three times.

**Sarah Palfrey Cooke** I only knew her to speak to. Every woman in tennis who has a reasonably good figure is always extolled by the press as being a "raving beauty," and Sarah was no exception. She was one of the top women players in my day, and she was married to another top player, Elwood Cooke. Elwood was a men's doubles winner at Wimbledon. In singles, he was usually nosed out by Bobby Riggs. I was one of Elwood's ballboys early on.

**Helen Wills (Moody)** She was a remarkable player, with the best ground strokes known to the game, male or female. "Little Miss Poker Face," the press called her, because she never cottoned up to them. She had a wonderful privacy about her. Even as a boy I sensed that, when she would come over to San Francisco from Berkeley for a practice match in Golden Gate Park. One of her favorite people to play was Larry Dee, an eighteen-year-old, then the number-one player in Northern California. (I, then seventeen, was number two.) I watched one of those Wills-Dee matches. It was very good. I'd love to have had a chance to hit with her, too, but that was never to be.

There's a court named for Helen near Chinatown, San Francisco. In a sentimental mood, Barry MacKay and I sought it out one day for a game. We found the court playable, but just barely.

# 15. Transitions

I'VE BEEN ASKED how many years I stayed away from tennis. None. I've always played tennis for exercise, for amusement, and for travel. And, when I was a young parent, for bringing my children along in the game. Only when I had necessary things to do, like work, go to court, look after my parents and children, tend to taxes, etc., did I stop all my exercise.

Please understand, exercise and *serious* tennis are two different things. For exercise I would go running. My daughter, Sue, runs six-minute miles six times a week. Must be in the genes. She was a pretty fair tennis player when she was younger but has too many responsibilities now to keep it up on a high plane. A person who does not practice for competitive events has given up his chance of winning.

When I was in my late twenties and beginning my law practice, I announced to the press that I was through with competitive tennis. I didn't mean that literally.

"Competitive tennis" to me meant making tennis my chief interest, playing all the tournaments and doing the very best I could. Earning a living by taking up an occupation was not consistent with that. This did not mean that whenever I had time or wanted to play, I would not be competitive. You don't change the spots on a leopard. I'm always going to be competitive. (Yes, even now in my eighties.) But I was not going to regard tennis as something for which I had to set aside everything else so that I could do my best.

I was mindful also that unless I played a number of tournaments I wouldn't be able to reach higher than sixty percent of my capability.

That reduced capability might be sufficient if I were just playing in my leisure time or doing a tournament for other reasons. But I consider anything short of a real effort not to be competitive tennis.

If you put yourself into top competition and you don't train for it, you're not giving competitive tennis a fair shot.

I was never in the mainstream of tennis after those three years of my heyday—1946, 1947, and 1948. I no longer had any hopes, dreams, or expectations of winning the principal tournaments of the world. I was determined to be a lawyer; I had no intention of pursuing serious tennis further.

Sure, I'd play in local tournaments and accept an occasional invitation to a tournament in an exceptionally pleasant place, like Hawaii. And I'd do my darnedest to play well. But I knew I could never have a tennis career if I didn't play and practice four or five times a week against good competition, be free to travel five or six weeks a year, and play in eight to ten top events that involved considerable travel to get to. That's what I meant when I said I was not going to be involved in competitive tennis anymore. And, of course, once you decide not to, quickly enough you find yourself incapable of competing!

Demanding game, this tennis. Some players I know can be competitive and juggle a happily married life, children, business involvements, and time-consuming benevolent projects. But they have helpers and business managers to take all the little details off their minds. And at least one has his own private jet plane for travel.

I've always tried to keep up my game sufficiently so that I could occasionally accept pleasurable places to go where there'd be room and meals, sometimes even transportation to get there, on the house.

In 1953, when I was thirty-one, I had a national ranking of eight, even though I was not playing what I consider to be competitive tennis. A third Davis Cup team invitation came along—Japan versus the U.S.A.—the match to be held in Vancouver, British Columbia. The Japanese then had a weak team, and the U.S.T.A. was quite satisfied with two of the top-ranking U.S. players, Tony Trabert and Ham

Richardson, to win their Cup matches. But an alternate was needed, in case either Tony or Ham suffered injury or illness.

I got the nod, not unaware that the U.S.T.A. was probably watching their pennies (as usual) and that the cost of flying me from San Francisco to Vancouver would be a hell of a lot less than flying a bigger-name player out from the East. I enjoyed being a sparring partner for Ham and Tony, and the trip in general was great.

About five years later, another Davis Cup event opened up for me. Again, the contest was to be in Vancouver—Mexico versus Canada this time. The Mexicans had an excellent team that year, Canada did not. The Canadians asked me if I could come up to coach and practice with their team. I was newly married then, to a girl from Vancouver, coincidentally, so the trip served a double purpose— tennis, and an opportunity to get to know my in-laws better.

Unfortunately, my coaching did not pull off any miracle event— Canada lost—and the visit with the in-laws was for naught. My marriage did not last long.

Quite early in my life, I started playing younger (than my) age divisions—a lot of tournaments around the San Francisco Bay Area. I played "down" only if I could not find sufficient competition in my own age bracket to give me a good workout. When I was in my forties, I would often enter the 30s or 35s, if they were open events. When I was fifty or fifty-five years old, I would enter the 40 age group just for the challenge. It gets harder to do this when you reach eighty, however. With more and more seniors retiring early from their businesses, throwing themselves seriously into fitness and tennis and keeping their running legs limber, it's all I can do to keep up with fellows my own age. I never thought I'd say that!

This is one of the few stages in life where, if you like to compete, you actually look forward to your next birthday, since veterans' matches tend to become a little easier the older you get. Doesn't always work out the right way, though. As my longtime friend, Vic Seixas, once remarked to me at a Grand Masters event, "I'd go to the draw sheet hoping to find that I had an easy match. And then it dawned on me that *I* was the easy match."

When I made my "comeback," after the children were grown and my legal practice was well established, the competitive avenues open to me were largely age-related.

About getting older—you'd just better adjust to it. If you're reluctant to grow older, and go play Wimbledon or the U.S. Open, or one of the other biggies, and lose in the second round to some player who's well down into the third rung but beats you because he's been playing tournaments regularly, that's no fun. You know you could dig in and get better, but you'd have to give up your existing life to do that.

Which decade has been the most fun for me? Without a doubt, when I was in my twenties, when my tennis was right up at the top, I had just gotten out of the army, had not yet gone back to law school, and was trying out for a place on the Davis Cup team. I wanted to play at Wimbledon, and in the Nationals, and I wanted to win, or at least do well.

And I did. Those were great years.

But my senior years have lasted a lot longer than my youth, and have given me a second lease on a tennis life. I didn't begin playing senior (also called veterans) tournaments until I was forty-seven. (You can be considered a senior as young as age thirty these days, but that was never for me!) The year was 1969, and I won the U.S.T.A. National Men's 45 Hard Court Championships.

Various veterans Cup events started for me quite accidentally in 1973. One of my friends in tennis was Emory Neale, a top player from the Pacific Northwest. He was a year or two older than I, and captain of a challenge called the Dubler Cup for the age 45 group. It was to be contested in Orange County, Southern California.

Emory wanted very much to recruit some well-known "sleepers" for his team, and since we had become reacquainted as opponents in the finals of a men's singles at La Jolla and had gotten along well, he asked if I would be available. "We would be happy to pay all expenses and pay you two hundred dollars besides," he said. "We are tired of losing to European teams."

And then came the carrot on a stick. "John Wayne's going to be there."

Naturally, I signed on. Who can resist the chance to meet John Wayne? Emory got Bobby Riggs and Hugh Stewart, too, among others. In my mind's eye, I can still see John Wayne and Hugh hard at it in the clubhouse in a backgammon game. Emory walked over to interrupt the actor, who was to open the traditional ceremony. "Are you ready, Mr. Wayne?" asked Emory.

The actor unfolded himself from his chair and rose to his impressive height. "Born ready!" he boomed, assuming instant command. And the matches were on. My team won. That was the beginning of my veteran Cup events, and I thank a chat with Hugh Stewart at that tournament for getting me started on more.

I knew Hugh spent a good part of his year playing in Europe, and I was curious to know how he swung it. "How do you get named to a team?" I asked him. "I'd love to get on one of those nice trips like you're doing."

"Well, Tom," he told me, "you just have to get off your duff and get out there and play a few veterans tournaments, win a national or two, and get ranked in the top ten senior players, which should be easy for you to do."

So I started to do that, got a national senior ranking, and was named to my first veterans Cup team when I was in my fifties.

There was a seventeen-year break, though, between my making much of a mark on the senior scene and when, at last, in 1986, at age sixty-four, I retired my private law business and settled down to—what else?—senior tennis again. I have since played on nearly all of these international Cup teams. Maybe ten or fifteen events over a like period of years.

If you had a ranking among the top four players in your age group, you were top meat for consideration. And you could qualify as a doubles or singles player.

All these Cups have four-man teams and if your credentials are pretty good you have a good chance of being tapped. About fifteen or twenty countries enter them, each with a team for whichever age group they've entered.

Those Cup teams meant for me that I could have a two-week

vacation wherever the Cup was being held. Now, if the team were gong to Lower Slobovia, or Outer Afghanistan, I wasn't applying. But quite often the team would be playing in France, Spain, England, Germany, Italy, Austria, South Africa, Buenos Aires…and those I would always go for. In addition to the Cup event, I would try to work in a separate international tournament nearby. There would be extra expense money, prize money, and allowances for those, so the trips, basically, paid for themselves.

At age fifty-five, I played the Austria Cup; at sixty-five the Britannia Cup; at seventy the Jack Crawford Cup; at seventy-five the Bitsy Grant Cup; and at eighty the Gardnar Mulloy Cup. The only long-established senior Cup team I never played on is the von Cramm Cup for sixty-year-olds. (I was busy working then.)

There is also a Billy Talbert Cup for men eighty-five to ninety. I would love to be the U.S. captain for that team!

Another Cup event I have greatly enjoyed playing is the Friendship Cup in Japan, where I have renewed friendships (thus the name) from the various other Cup contests and major events like the International Tennis Federation Veterans' World Championships.

Cup events have always been attractive to me—at least ten days to get away from work and other obligations and go to a place I'm genuinely interested in finding out more about. I'd happily work like hell when I got home to go on those trips. Occasionally, I took my children (no more than two at a time), rounding out their education in several ways—besides its being just darn pleasant for me to have their company.

Don't mean to toot my own horn, but you might find it interesting as a matter of record of how much an older person can achieve in tennis, if he tries. In 1987, when I was sixty-five, I won the U.S.T.A. National Men's 65 Hard Court, Grass Court, Clay Court, *and* Indoor Championships, and, with Bobby Riggs as partner, the National Men's 65 doubles titles for all but the Clay. The U.S.T.A. ranked me number one in the 65s for the next seven years, with the exception of 1992 when they dropped me a notch to number two.

In 1988, at sixty-six, I again won the National 65 Hard Court and

Indoor, also the International Tennis Federation Men's 65 championship, and was named number one in the *world* for the 65s.

In 1989, age sixty-seven, the National 65 Hard Court and Indoor were mine again, along with the national doubles title in both those events with Fred Kovaleski. The I.T.F. again ranked me number one in the world for sixty-five-year-olds.

In 1990, age sixty-eight, I again won the National 65 Hard Court and Indoor singles, along with the doubles in both events with Fred.

In 1991, age sixty-nine, a repeat of the National 65 Hard Court and Indoor, and, again with Fred Kovaleski, the doubles of both.

In 1992, the year I turned seventy, I won the National 65 Hard Court singles and, playing for the fourth time with Fred, the National 65 Grass Court and Clay Court doubles. For good measure, as a sort of birthday present to myself, I took the National 70 Grass Court and Clay Court Championships. This earned me the number-one ranking in *both* the U.S. and the World for 1992–93.

In 1993, age seventy-one, I again won the National 65 Hard Court, and also the National 70 Clay Court. Later that year, I underwent shoulder replacement surgery.

In 1995, age seventy-three, with the help of my now-working right shoulder, I won the National 70 Hard Court and also the 70 Clay Court Championships, and was ranked number one in the 70s by the U.S.T.A.

In 1998, age seventy-six, despite an increasingly bothersome knee, I won the National 75 Hard Court and Indoor Championships.

At the time of this writing (springtime, 2006), there are only three major players from the mid–1940s still actively competing. That would be Gardnar Mulloy, Fred Kovaleski, and myself.

I should perhaps delete myself, for I have not yet fully recovered from total knee replacement surgery done in 2004.

But I do intend to become competitive again.

The fates permitting.

# *Match Point*

# 16. My Favorite Courts

I'VE HEARD PEOPLE SCOFF that a tennis court has no atmosphere. That if you've seen one, you've seen them all.

Nonsense! Here are my favorite ten tennis courts in the world—and why.

1. Centre Court at Wimbledon, England. Because it is kept in outstandingly good condition, and has all the aura that golf has with its Old Course at St Andrews, Scotland.

Never is Centre Court open to play by members of the All England Lawn Tennis and Croquet Club (as Wimbledon is formally known). It is saved for very special events such as the Championships. The court is excellently cared for by a first-class groundskeeper and a dedicated crew who are unrelenting in their attentions to it. There's a special canvas kept at the ready to cover the court when it rains, so play is never unduly interrupted. To watch the grounds crew whip the cover out is to marvel at their snap-to efficiency. A retractable roof is in the offing for Centre Court, but I'm told there will always be a need for the old-fashioned way, as the new roof will take quite a while to close.

The grass is kept never too long, never too short, so it maintains a good root system. It is a spine-tingling experience just to be there. It is the most famous court in the world.

2. Center Court in the stadium at the West Side Tennis Club, better known as Forest Hills, New York. Frankly, I'm out of date with this one, because I don't know if this court is even used for important events since the U.S. Open moved to Flushing Meadows. I hear

West Side has largely dispensed with grass, as has Australia. But that Center Court was fine because of the care they gave it. It was the court on which most Davis Cup finals were held. Those days seem to be gone forever, since the Davis Cup Challenge these days is held on hard courts or clay.

3. Army-Navy Club in Arlington, Virginia. I love the surface there. It's regular, even, good quality clay, the green kind, the best. All the courts are kept in excellent condition and watered regularly. It does rain there occasionally, but that's not all bad because rainfall often improves a clay court.

The staff is efficient about running the tournament, and yet there is a seeming air of appealing casualness about the Army-Navy. The club is in an area where there is very little wind most of the time. It is a beautiful area, interlaced with a golf course that President Clinton had just finished playing one time when I was there. He came over to the tennis clubhouse to wish us all well.

The club is just over a hill from the Pentagon, and those of us who were there playing the Veterans' National Clay Championships on September 11, 2001, watched, stunned, as the doomed plane of American Airlines with terrorists at the controls passed low over the tennis courts and disappeared over the hill. We heard the boom as it hit the Pentagon.

Tournament play went on, incidentally. It had to. It was the final day of play.

4. The Berkeley Tennis Club, Berkeley, California. I have always liked it because it's in a sheltered area, in the lee of a hill, and the surface of the courts has always been impeccable. For years they hosted the Pacific Coast Championships, in my day considered one of the biggies on the players' circuit. It was in a league with the Los Angeles Tennis Club's Pacific Southwest tournament.

Many outstanding players called Berkeley their home club: Don Budge, Helen Wills, Helen Jacobs, and, a bit before my time, Hazel Hotchkiss, who became Mrs. George Wightman, founder of the women's Wightman Cup Team. The club is a hundred years old. A lot of atmosphere remains from the old days.

When I was a boy, a streetcar used to rattle between the courts, bringing people (and players) from and to the ferries that crossed San Francisco Bay. The club was the end of the line. Play would stop while the car came in, backed up, and went out again. I took my first serious tennis lessons at the Berkeley Tennis Club, and I loved the ferry-streetcar way of getting there.

Not the least of Berkeley's attractions is being next door and nestled at the foot of the huge white rambling Claremont Resort and Spa.

5. The Number One Court at the Los Angeles Tennis Club, Southern California. An excellent example of a top-class hard court. Its surface is regular and even and favored by year-round good light. When Perry T. Jones was in charge, tournament conditions were impeccable, line court judges very skillful (and never wrong).

Being near Hollywood, the grandstands used to be graced by movie starlets and their handsome escorts. I doubt that that's changed. This is show biz country, after all! At the nearby Beverly Hills Country Club, I remember looking up once and seeing Lucille Ball eyeing me. Well, she was really there to watch my opponent, her son, Desi Arnaz, Jr. He was about twenty-five years younger than I. A surprisingly good player, and, yes, he beat me that day.

6. The clay courts at the New Orleans Country Club, Louisiana. Made of green clay, great for vision, and it was thrilling to go out at night and be treated for dinner at Antoine's and taken to hear jazz along Bourbon Street.

Hurricane Katrina dealt a devastating blow to New Orleans, but I hear the tennis courts endured far better than the golf courses. And you know that old saying, the South will rise again.

7. The Country Club of Monte Carlo, Monaco. Beautifully kept clay courts, rolled and watered to perfection. They are terraced into the hillside, no wind, and what ambiance! The courts are lined just as they should be, picture perfect, with each court fenced off from its neighbor.

The views are transcendental. You look out to the Mediterranean, onto a lovely bay, just around the bend from where fancy yachts

dock. There's a huge jacaranda tree in the main area of the club, which seems to be forever in bloom with large purple blossoms. And there are rows of cypress trees here and there.

At the bottom of a hill, a train runs along, and if you've read this book so far you'll know I've always been a softie for trains. Monte Carlo has everything—and the food is superb. After all, it's French cooking, so "how can eet be bad?"

8. The Number One court at The Olympic Club, Lakeside, San Francisco, California. Like Berkeley, it's in the lee of a hill. The bottom of the hill was cut away in 1936 to make room for the tennis courts. They were built so that Davis Cup matches of 1937 could be played in California. It was the United States versus Japan. The U.S. won—5–0. Don Budge and Gene Mako were the players.

At The Olympic Club, the hill slopes down on three sides so there is no wind to contend with. It is totally protected all the time. The courts are level, a very good surface, redone regularly as needed, and there are walkways around the courts so you are never interrupted by other players (or spectators) crossing behind or in front of you. Hiking down the steep hill to the courts is easy; climbing back up can be a problem if you've had a tough match.

Beautiful surroundings include The Olympic Club's championship golf course. The courts used to have a dependable timekeeper who let us late afternoon players know by his actions when it was about to get dark. This was a large gray fox who emerged from the south and cruised the western side of the hills for his evening meal. When players saw him, we knew we only had five minutes of daylight left to finish our match.

This was before lights were put in for night play. But I like to remember the old way. And I bet the fox does, too.

9. I wish I could still name the Hyatt Grand Champions court setup in Indian Wells (Palm Springs area), Southern California, as one of my favorites. It was great in my day, a plethora of sheltered, well-kept courts with an excellent asphalt surface (my favorite kind) in a beautiful exotic setting.

Alas, times change, and although there are still a few courts left at this particular resort, the majority were bulldozed away a few years ago to make room for condos and a huge spa. A large development, the Indian Wells Tennis Garden, has sprung up down the road. A 16,000-seat stadium, built to host major tennis matches, is there, and something like twenty hard courts.

So I give my nod these days to the Mission Hills Country Club. It boasts all three court surfaces—grass, clay, and hard courts. You can still feel tradition in the air there, when Dinah Shore was queen of it all. Mission Hills is kind of old fashioned, compared to the others, but I'm an old fashioned kind of guy.

Many other resorts have taken over the glamour and gloss of tennis (and golf) in the Palm Springs desert. All are scenic with palm trees and mountains all around. Marriott's Desert Springs, Rancho Las Palmas, La Quinta, and P.G.A. West come to mind.

10. The La Jolla Beach and Tennis Club, La Jolla (San Diego area), California. Their principal court is beautiful. It is right on the ocean, with a mild and gentle climate. Important championships have been held there. The club itself is a lovely, low-key place. There's a central patio where you can have lunch and eye the bathing beauties at the swimming pool at the same time. A gorgeous white sand beach fronts the club.

La Jolla managed an incredible transformation recently when they hosted an early round of the Davis Cup. They replaced their pitch-and-putt golf course (temporarily) with a tent city and a truly splendid stadium. By now, it will be back the way it was but if you had seen it then you would have agreed—very impressive.

11. For good measure, I add here, in gratitude and for sentimental reasons, Court One at the California Tennis Club in San Francisco. It was named for me, with a handsome plaque attached to the outer wall, at a gala party the club hosted on my eightieth birthday in September, 2002. Actually, I try to avoid playing on Court One these days. Too many distractions from passersby and heckling friends. But it was (and is) a very nice honor, and a very attractive court.

### How To Get On Practically Anywhere

GENERALLY speaking, I have never liked courts that are windy, uneven, at an altitude, in extremely hot places like the equator, or unfavored by pretty girls.

Nine of my ten favorite courts are at private clubs, the exception being La Jolla, which is also run as a resort hotel. If you're staying there, you're considered a temporary club member with playing privileges.

Mission Hills also has a hotel on premises, but with its own tennis courts for guests.

The Claremont Resort, next door to the Berkeley Tennis Club, has tennis courts that are in a class with its famous neighbor.

Public accessibility to courts is more democratic overseas than here at home. The custom in the U.S. is you cannot play at a private club unless you have an invitation from a member, or from the club itself. We are a bunch of prudes.

In Europe, the custom is different. They are happy to increase their revenue by renting their courts to members of the traveling public. You can go, unannounced, to the top club in town, find the office or whoever is tending the bar, and say "We are tennis players. May we play tennis sometime while we are here?"

Never be pushy. Do not be an ugly American. Do not throw your weight around. Simply identify yourself as a well-behaved member of the public. State that you do not have a membership at that club, but would be very pleased if it were possible to have a game there. More than likely, the secretary will pull out his or her book and give you a choice of times for such-and-such a day. "Certainly, we can accommodate you," she'll say, "and our rates are such-and-such." And away you go.

If you do not have a playing partner traveling with you, here's another ploy. Make a date to have a "playing lesson" with the pro. Announce that you'll provide the balls. If the pro says that the fee includes balls, tell him that's fine, but you'll tip the ball boys anyway. For that's another great thing about playing in foreign countries; almost always there'll be ball boy service.

At the best tennis club in Athens, Greece, Hugh Stewart and I did this. We walked in cold. Just two traveling Americans who wanted a tennis game. We were granted a court very courteously. When we were changing sides, a gentleman came over and introduced himself as the club manager.

"I've seen you both play at Wimbledon," he said. (We were more known than we thought.) "Please come here anytime you want," he said. "I've told the office not to charge you a fee."

Now, you could not do that in San Francisco. Not at my home club, the California Tennis Club. Certainly not The Olympic Club. Nor any other private club that I know. Maybe the manager could use his discretion; I don't know about that. But when I wanted to bring the daughter of Betty Nuthall, a well-known British player, to play at the Cal Club, I had to follow protocol just like anybody else. Introduce her first, being a member of the club. She could not have walked in on her own, as we did in Athens.

Another "entree" is to provide in advance to the secretary of the club the name of a member friend who belongs to the club.

England is the only country I know that follows the same stuffy customs that U.S. private clubs have adopted. Without a member in person to take you under his wing, no way will you be allowed in.

Here's a possible exception, though. Be alert, wherever you are, to let it be known that you're going to such and such a town and would like to have a game there. The Queen's Club in London is quite exclusive. It's where the players go "for a knock" before their matches at Wimbledon. But at a dinner party in France once, I mentioned that I was on my way to England, and one of the other guests volunteered that he was an officer with the British Lawn Tennis Association and if I would like to play at Queen's, all I had to do was ask and he would set it up. So that's another possibility.

My father used to say the way to get into a private club was to just walk in as if you didn't give a damn whether you were wanted there or not. Dad was always an optimist.

However, Dad's casual attitude toward private clubs worked for my children and me on a vacation in Tahiti. Our hotel did not have

tennis courts, but we heard that a Club Med on the island did. There were no reciprocal privileges, so we took a chance. Hopping on bikes, with our tennis rackets over our shoulders, we pedaled to Club Med and gaily waved to the man at the security gate as if we were *gentils membres* returning from an outing. He waved us in, without challenge. We had a lovely day. In fact, we did it for a number of days, working the same ploy.

In general, I find that if you're a decent person, and not swaggering or walking over people, and if you're grateful and interested, happy, pleasant, and nice to come in contact with, you're going to be treated well. If you're not, shame on them, not on you!

If you can speak a few words of the local language, that's an entree too.

# 17. Wimbledon Aftermath

SEEMS AS IF WIMBLEDON and I have always been soul mates. When I was forty, in 1962, I felt the urge to go back.

It had been fourteen years since I'd last played there, and it had been a tumultuous time of working hard at my law practice and trying to cope with a failing marriage. My wife and I had produced three fine children, but the basics for building a happy family life just weren't there.

Perhaps what we needed was a vacation? Just the two of us? My parents said they'd be happy to take care of the children, ages one to three. Offer accepted, so off we flew from San Francisco to Europe.

My wife did place one difficult condition on our travel; the food, accommodations, etc., should be exactly as comfortable as they were at home. Impossible, but I tried—a little too enthusiastically in hindsight. I planned the trip to include not only Wimbledon, but very nice hotels in France, Germany, and Switzerland.

At Wimbledon, I was able to muster up enough experience from the past to defeat the British junior champion, Graham Stilwell, in five sets in the first round. It was quite a tussle. I lost the first set 8–10 and the fourth 5–7, and was damn lucky to squeak out a win. I didn't get much further in the tournament.

Traveling on to the continent, we visited Le Touquet, Garmish-Partenkirchen, and Villars. By the time our three-week vacation had ended, a fourth child, Sally, had been conceived. Born in March, 1963, she's a jewel, and has always been a joy to me.

When 1964 duly rolled around, it was a rocky year for me, per-

sonally speaking. Along about the time Wimbledon entries were to close, I received a phone call from Peter Herb, then secretary of the Northern California Tennis Association. He sounded a bit miffed.

Wimbledon had phoned the N.C.T.A., he explained, saying they had saved a space for me in the tournament but had heard rumors I was not coming. Was I, or wasn't I? They wanted the N.C.T.A. to confirm.

In those days, players had to apply to their local chapter of the U.S.T.A. for permission to enter international competitions. There was an "eight week rule" we were all expected to obey. They wouldn't let us play a total of more than eight weeks of tournaments a year, and we were expected to support chosen tournaments at home.

"Pete," I said. "That's strange. I never entered Wimbledon." And then a sudden thought entered my head. It would be a great relief to get away for a few days from the turmoil at home. Why not go if the N.C.T.A. would let me? Hastily, I added "But you know, Pete, I *meant* to enter. Can you expedite it for me?"

To the N.C.T.A.'s credit, they did. But you might find amusing the paternal tone to the letter they sent me. I did, which is why I kept it all these years.

Dated May 18, 1964, it reads "The Executive Committee (of the N.C.T.A.) met yesterday at the Peninsula Tennis Club in Burlingame. After some discussion, it was decided to approve your player application for international competition at Wimbledon. We were unhappy that you did not compete in the National Men's 35 (Brown's note: I was then forty-four!) Hard Court Championships in Mill Valley. We expect you to play in the Pacific Coast Internationals in Berkeley in September. Your application for international play has been approved and forwarded to Bill Clothier on this date. Wishing you every success as a representative from Northern California, Sincerely, Bill Hoogs, President."

Whew. What a relief. Wimbledon to the rescue!

I traveled alone this time. Far more harmonious.

The first round was rather like the match of the year before.

Again, I drew the current British junior champion, Gerald Battrick that year, and defeated him with no particular problems. But in the next round I yielded to John Newcombe, who subsequently won the championship.

It was another bunch of years before I had another opportunity to play Wimbledon. Both trips were in the 1970s, and the first was my initiation into their "Gentlemen's Veterans Doubles." (An event no longer held.)

My partner was Bob Tout, an old teammate from college. For him, to play there was the dream, quite literally, of a lifetime. Bob had a lingering illness (although we didn't know how serious it was at the time). We did very well—I remember the great Jean Borotra teasing us before we took on him and his partner, "You two look much too young. May I see your birth certificates, please?" Jean was seventy-three at the time, and, I believe, the oldest competitor in Wimbledon history.

Bob Tout and I reached the semifinals, where Vic Seixas and Straight Clark killed us. They became the veteran winners that year of 1972.

My next chance to play Wimbledon was a fluke—I was a last-minute substitute for a Grand Masters event in England. And I mean "last minute"! At two a.m. on a Tuesday night in June, 1977, I woke to a phone call from London from Al Bunis, then the Masters organizer. "Torben Ulrich has a bad knee and cannot play at Nottingham this weekend. We have been invited to play at Wimbledon, too. Can you be here by Friday?"

Well, there was that siren call, Wimbledon, again. Of course I could be there. My two oldest children, Mark and Wendy, were teenagers by then, school was out, and their passports were in order, so off we flew with a side trip to Switzerland afterwards, promised by me as a dividend.

I found a pick-up partner for the Wimbledon men's doubles that year, Gene Scott, who had just recently founded the magazine *Tennis Week*. Gene was an excellent player, a U.S. Davis Cupper in 1963

and '65, semifinalist in the national singles in '67, in the U.S. top ten a number of times. Because of our past exploits, our match was assigned to Court One. We lost to the British Davis Cup team, but it took them five sets to win. Not too bad a performance for such an unexpected trip on my part, but I was sorry to disappoint Gene by not advancing further. He played far better than I.

## Mod Move

TRADITION may be uppermost at Wimbledon, but the Championships made a major breakthrough in 1968. That was the year they leveled the playing distinction between professional and amateur by declaring their tournament "open" to anyone who could qualify to play there.

The U.S.T.A. was shocked. "We won't go for that," they said. "We will continue to have only amateurs in our competitions. We will not let in players who play tennis for money."

"Do what you like," Wimbledon in effect told the U.S.T.A. "We are only going to have one category—Player. We want to attract the best players in the world, and going 'Open' is how we will get them."

The U.S.T.A. did an about-face.

## Last 8 Club

WIMBLEDON has an endearing custom. If you have played in "The Meeting," as they also like to call the tournament over there, and have reached in any year the quarterfinals of any event—singles, men's and women's doubles, or mixed doubles—you become eligible to be a member of their "Last 8 Club." And what a privilege that is.

"Last 8" was founded in 1986 as a club within the All England Club, to celebrate the one hundredth holding of the Championship established back in 1877. (Yes, I know that doesn't add up right, reason being no Championships were played during World Wars I and II.)

To be recognized for the rest of your life as one of the last eight players remaining in the tournament at any year in the past is mar-

velous. You, and your guest, are given a pass for the entire two weeks of play.

Last 8 Club members and guest (no more than one) have entry to a hospitality suite where drinks and light snacks are on the house. There is also a very palatable à la carte menu, complete with Wimbledon's famous strawberries and cream. Hospitality extends to getting you London theatre tickets.

On my first visit as a Last 8-er, I had cause to test the theatre service with the hottest show in town at the time, "Les Misérables."

"Where do you like to sit?" I was asked. "Well, first balcony, first row, center section, preferably on the aisle," I answered. "We'll call and see what we can do," they said, and they did it. (The sooner in the week you ask such favors, the better your chances of getting them.)

As for the tennis, a few reserved seats are usually available for select matches on Centre Court and No. One Court. There are four other "show" courts that your pass allows entry to—courts two, three, thirteen, and fourteen.

It is a darn nice privilege to be a member of the Last 8, so you can imagine my delight one February day in 1989 when I received an all-expense paid invitation to return for the Championships that summer.

There was to be a special tribute to those of us who had participated in both the pre- and post-immediate World War II meetings.

I was sixty-seven. It had been forty-three years since I had first had the thrill of playing there. And now I was to be an honored guest. Among other "Last 8-ers" who came: Don Budge, Jack Kramer, Budge Patty, Jean Borotra, Enrique Morea, Pauline Betz, Louise Brough, and Margaret duPont.

We all sat in the Royal Box, went to the traditional Ball, enjoyed the Members Enclosure, and partook of the Champions Dinner at the Savoy. And, yes, enjoyed the tennis. (The Germans were victorious that year. Steffi Graf and Boris Becker took the singles.)

That's Wimbledon for you. They make you feel as though yesterday has become part of the present. As, of course, it has.

In the year 2006, that cherished invitation from the Last 8 Club came again, and once more was irresistible. I took my lady, Lee, co-author of this book. Her first time. My ninth. I was astounded by the many physical changes since I'd last been there.

Like Topsy, Wimbledon just grew. And is still growing.

The iron gates that seemed so huge in my youth have been dismantled, replaced by new ones, and relegated "for sentimental purposes" for display only at the far end of the property.

Private cars no longer drive into the grounds (unless it's the Queen arriving).

The black and white weather forecast balls atop the flagpole are gone.

The elegant tea lawn has been replaced by block paving.

The players' entry is on foot now, where we used to be driven *out*, on Somerset Road by the splendid new Millennium Building. (The old Number One Court is buried beneath it.)

Competitors today have an elegant skytop complex, complete with lounge with Internet sets that are always busy, a cafeteria with view over the entire club grounds, the most modern of locker rooms, a gymnasium, a spa, etc.

And they have an elevator now (a welcome addition, since Wimbledon requires an awful lot of walking).

The constant escort requirement before one's match on Centre Court has been relaxed a lot. But players are still called early, and reminded to be ready when summoned to play.

### My Lady's Goof

HERE'S an experience Lee had that might amuse you.

She tends to be rather naive sometimes. One early afternoon she found herself alone with an attractive young man in the elevator descending from the competitors' lounge to the ground level.

"Are you playing today?" she asked him. (Clever girl. He was in tennis clothes. What else would he be doing?)

"Yes," he answered.

"When?"

"Now."

"Where?"

"Centre Court."

"Oh," she replied, rather flustered. "I'm sorry I didn't recognize you."

"That's all right," he opened up. "Nobody does."

"Well, good luck!" she trilled as they parted company.

The player turned out to be Jarkko Nieminen of Finland, seeded number twenty-two in the tournament. He was on his way to play Rafael Nadal, the number two seed, in the quarterfinals. We watched the match from excellent seats and thought Jarkko did a very credible job competing against the Spaniard. The score was 6–3, 6–4, 6–4.

### Living History

DUCKING in and out of the Last 8 clubroom was a major part of my pleasure, this sixtieth anniversary year since I had first played there. You never knew what old player/friend was going to stroll through the door next. Most of us have white hair (or no hair) now, and it was wonderful to renew kinships with Budge Patty, Jenny Hoad, Pancho Segura, Tony Trabert, Armando Vieira, Anand Amritraj, and Bill Sidwell.

Almost forgot to tell you of another thrill that happened to me on the '06 visit. Wimbledon has a fine new tennis museum and library. The museum is open to the public year-round, and is very entertaining and interactive. You can push buttons to make various exhibits come to life. There is one where you can select whatever decade at Wimbledon you want to see highlights of. I chose the 1940s and was surprised to find myself in film, with live commentary by a Brit newscaster of the day identifying me by name as I flailed around the courts against Petra and Segura, and against/with Kramer.

It also showed me playing the winning men's doubles and mixed doubles of '46 and also in the royal box in '47 with Jack Kramer

meeting King George, Queen Elizabeth, and Princess Margaret. Quite a feeling to know I am considered a bona fide "historic" part of Wimbledon!

Here's a major change from the days of my youth. Players on Centre Court are not expected to bow to the Royal Box anymore (unless the Queen herself is present). But the two finalists at the awards ceremony *are* expected to turn around and acknowledge the *press!*

The 2006 finals I watched between Roger Federer and Rafael Nadal was perhaps the best tennis display I have ever seen between two equals. Roger and Rafael made Centre Court seem small.

My seat was just behind the British actress Judi Dench. I'm told I showed up on your TV screen when the camera zoomed in on her briefly.

## 18. Traveling Man

ONLY ONCE have I gotten sick on a trip—that Davis Cup trek to Australia when I was a young and foolish twenty-three. But several of my travel companions since have been felled.

On a tennis trek to Indonesia, my doctor at the time, Len Saputo, forgot about that wise old expression, "Only mad dogs and Englishmen go out in the noonday sun." What a terrible case of sunstroke he got, by forcing himself to do intensive practice on the courts not only at high noon, but also practically upon arrival in that searing hot country after twenty-seven hours of air travel. He was one sick puppy, but as I recall he somehow made all his matches.

In India, on a non-tennis trip one year, I wondered why Patricia, my usually talkative lady companion, seemed to have lost her voice. Frantically, she scribbled notes and flung them at me, and I finally got the picture. She couldn't talk because she couldn't breathe! Some mysterious allergy had come from nowhere to strike her down. Fortunately we were staying at a four-star hotel (something I rarely do), and emergency medical attention was quick to respond. End of that trip. We had to cancel the rest of it, and fly home immediately.

Oh, I've had bouts with the occasional "turista," but that doesn't count. Long ago, on a trip to Mexico, I learned about the wisdom of taking nonprescription acidopholous tablets at the first sign of trouble.

More of an annoyance to my penchant for travel have been necessary time-outs for rehab from various surgical procedures—having

to have tendons repaired on both hands, a faulty shoulder replaced, and a total knee replacement.

About packing for a trip: I've always believed in traveling light. When I was young, I was very well-organized. I had a three-page single-spaced typed list of what to take and a handy place to lay it all out—the living room floor. I remember my father watching bemused from his big easy chair as I threw everything into piles according to my list. "I won't say a word!" he assured me as my personal deadline approached.

These days, I admit to just tossing things at random into a suitcase, the easy expandable type with wheels. I find I can get along very well with an ample supply of underwear, socks, tennis shirts, shorts, a warmup suit, blue blazer, gray slacks, and one dress shirt with a collar that will take a tie and not strangle me when I tackle the last button at the top.

My tennis shirts I prefer to be cotton, not synthetic, and with a long tuck-in so they don't come out when I'm playing. My only requirement for tennis shorts is that they not be too tight in the crotch.

My biggest concern is tennis shoes. I'm in big trouble if I lose them, or if my luggage goes astray, so I always carry two pairs. I have special shoes for grass courts, and a different pair for clay courts, both made by Dunlop. For hard courts and everyday wear, I am partial to Tretorn because they're as comfortable as old slippers, and very light, which reduces court fatigue.

As for dress shoes, I've found that a good pair of loafers will take me anywhere.

I like female company when I travel. But, I'll be blunt, some of them have tested my patience. Edwina, for instance, whose talent as navigator in a rental car in Spain left a lot to be desired. We got a late start (she overslept), leaving from Madrid for a tournament on the Costa del Sol. It is a mountainous drive, quite harrowing in spots, and takes a lot of time. We got lost several times. Arrived at the tournament so late I was disqualified.

How late? A day and a half.

Edwina was fond of doing needlepoint. Accompanying me on a tennis trip to Hong Kong, she dropped a needle on the carpet of our hotel room. She never mentioned it. Inadvertently, I stepped on it and wondered why my foot became so sore during the tournament. Upon returning home to San Francisco, an X-ray revealed the culprit. It took two surgeons to pry the thing out.

Another traveling companion was Yvette. A fiery temper had she. But I had cause to thank her for it at dinner in a quaint restaurant in a resort town in France. It looked charming from the outside, although it had a sign outside that should have warned us off. "English Spoken Here." I have found that those three words almost always lead to a tourist trap. But we were hungry, so we entered and took a table.

The waitress, who was also the proprietor, took our order in a most surly manner. Slammed the cutlery on the table. Plunked the glasses down so that they spilt.

Up till then we had spoken only English. Yvette, I could see, was seething. "Okay," I told her, "let her have it." And in a torrent of French, Yvette let fly with verbal comment that dissolved our grumpy waitress like a puddle. "We will pay only for the bread and butter charge," Yvette declared. And out the door we went.

I must say, it was refreshing that an old credo of mine, "Feet, take me out of here," was tended to by someone else that night.

Although I prefer company when I travel, I have no aversion to traveling alone. Sure, there are lonely moments, and then I take refuge within the pages of the *New York Herald Tribune* or the *Wall Street Journal*. I've found that my passion for chocolate and the nearest candy store also helps me forget that I'm lonely.

In foreign countries, I like to travel footloose, with no particular hotel reservations. In France, my favorite way to locate a nice place to stay with atmosphere and a good dining room is to find an elderly lady walking her dog.

I don't hit her with a question right away. I say a cordial "Good evening" or whatever time of day it is, "How are you?," "Is your dog

well?" and then I get to the nitty gritty. "*Un bon hotel avec un restaurant?*" I tell her "a million thanks," or something like that, and, gee, she'll have sent me to a beautiful little hotel just a couple of streets away that I never would have found otherwise.

It's always good to be able to speak a few words of the language. But you'd better be sure you pronounce it right. In Spain, once, I heard a young female American tennis player ask her Spanish male escort if she could borrow his comb. Well, the word for comb in Spanish is "*peine,*" and the way she said it, it came out, "May I borrow your penis," which, of course, brought down the house.

Once, in Mexico City, I was alone in the subway around midnight, still in my tennis clothes from the afternoon, with nobody else around except a sour, surly, mean-looking individual who eyed me with suspicion and what could have been interpreted as threat. I said the quickest and surest thing that I knew how to say correctly in Spanish, "*¡Viva Mexico!*"

His face lit up and he was all smiles and genial. What might have been an uncomfortable situation was avoided. A few cordial words in the local language always comes in helpful.

My most rewarding experience speaking a language not my own was in Buenos Aires. In 1995, I won the Argentine National Championship (in my age division) and was asked at the farewell banquet to respond—in Spanish—on behalf of my fellow competitors who spoke only English. Made me feel quite useful, and I'm told my accent (ahem) was excellent.

Tennis players, I've found, are born foragers. We like to live off the land. Our sport, so one-on-one, so intimate, gives us a unique entrée to mixing with local people. And if you can speak some of the local language, so much the better.

Three times (so far) in my life, I've taken a month off to go to another country and immerse myself in a language school. Since Spanish was my minor at college, and spoken widely in my hometown of San Francisco, that's been a natural for me to pursue. I'm also enamored of the French language.

The first time I did such a school was a do-it-yourself experience. I flew to Cuernavaca, Mexico, checked myself into a small inn, hired a taxi, and asked the driver to take me to the best language school in town. After a few hits and misses, I found a good one and signed up on the spot.

I played hookey from school one day. Longing for a game of tennis, I looked up one of the Vega brothers, against whom I'd played many years before. A fortunate call. He remembered me. Best yet, he owned a tennis club. "Come on over," he invited. "My club is your club. I've told my pro to find you a game."

Such is the hospitable world of the tennis player.

Since Mexico, I've tried finding language schools an easier way— through the Eurocentres people. You can find them on the Web. More formally known as the Foundation for European Language and Educational Centres, and based in Zurich, they offer ready-made and reasonably priced packages in the country of your choice, with language school every day, private room in a local home, and class outings for sightseeing. I've done this in La Rochelle, France and Madrid, Spain.

Each time, I was, by far, the oldest student in the class, which was kind of fun, and not at all awkward, mixing with young people from a variety of countries, all there with the same purpose in common.

I also found this language immersion to be practical for everyday travel situations such as bargaining with taxi drivers, shopping for picnic food, and getting places by public transportation. I far prefer feeling "at home" in a country to feeling like a tourist.

This does not mean that I do not like to go sightseeing! As my Aussie friend, Billy Sidwell, says, "I have a sticky beak." I'm curious. I want to know. I want to see whatever there is to be seen. I want to be soul-stirred, emotionally touched, and moved. And I *have* been stirred, most notably, by the Hiroshima Peace Memorial Museum in Japan, the Taj Mahal and the Caves at Ajante in India, the sphinx and the pyramids in Egypt, and the incredible ruins of Machu Picchu, Peru.

Ever since playing in the French Open, I've been interested to know more about Roland Garros, for whom the tennis stadium in Paris is named. I knew he was a World War I aviation hero who had single-handedly destroyed a German machine gun nest located at a strategic portal of Paris. I knew that he had been killed in that mission.

In a French Open souvenir program, I learned that Garros was born on the French island of Reunion in the South Indian Ocean off Africa. I wondered what it must have been like for an island boy to travel so far and become such a worldly hero. I got it into my head that I must travel to Reunion and get a feeling for the man.

After a Cup tournament in Johannesburg, I flew to Reunion and found it a very pretty island. Tributes to Garros were all over the place. A road sign here, his childhood home well marked, and a fine statue to him in the town square. Reunion was well worth a side trip.

Rarely do I travel without my racket, even if it's a trip solely for sightseeing. In New Delhi, India, in my seventies, I was invited for a game of doubles at the elegant Gymkhana Club. We were all about the same age, gray-haired, and strangers, or so I thought. Sitting around over cups of tea afterwards, one of the Indians casually said to me, "I understand you played at Wimbledon."

"Well, yes, I did," I replied.

"So did I," he countered.

"Oh, really? What year?"

"In 1946 and 1948," he answered.

Hmmm. I was intrigued.

"That's interesting," I said. "I was there those years."

"I know," he smiled.

"And how far did you get?" I asked.

"The round of sixteen," he answered.

Gee, I thought to myself, he must have been pretty good to get that far. Aloud, I ventured, "And who did you lose to?"

"Why, to you, of course. Both times."

I was taken aback. He roared with laughter. It was Sumant Misra. He had thought I was setting him up.

To have your tennis and the means and desire to travel, too, is to have the best of both worlds. Senior players, both men and women of any age from thirty-five up, have a wonderful source for making this happen— the I.T.F. (International Tennis Federation) Seniors Circuit. By using their ingenious calendar, which you can order by mail or pull from the Web, you can literally travel with a racket anywhere in the world, any week of the year, to a tournament where you're sure to find congenial people.

Countries participating are the U.S., Canada, almost everywhere in Europe, South America, Australia, New Zealand, the Caribbean, Mexico, Africa, Egypt, India, even Pakistan.

Surprisingly, you can find a tennis tournament in Europe even in the dead of winter. (They play indoors in lousy weather.)

The I.T.F. calendar lets you easily scan which tournaments are restrictive to which age groups. You can even be selective as to the court surface of your choice—be it carpet(!), hard court, indoor, Har-Tru, grass, or clay.

My longtime pal Hugh Stewart has been playing the I.T.F. summer circuit in Europe for years. He happily gallivants around the continent between his winters in Hawaii and autumns in Idaho.

If you'd like to sample the I.T.F. Seniors Circuit yourself, here's the address to write for their calendar:

Seniors Dept., International Tennis Federation
Bank Lane
London SW15 5XZ
Great Britain
Or, for you computer literates, www.itftennis.com/seniors.
Or e-mail them at: seniors@itftennis.com

### The Princess and I

I GUESS the most glamorous tennis trip of my life was an invitation from Merv Griffin to Monte Carlo.

It was my first contact with him since my youth, when he was a teaching tennis pro in Burlingame, California and one of my earliest boosters.

Now famous in the entertainment world, he was filming a show for television and I was invited, along with Barry MacKay, Hugh Stewart, and a few other players, writers, and movie people. Some of the scenes were to be shot at the Monte Carlo Tennis Club. We were put up at the Hotel de Paris.

The beautiful actress Dina Merrill was there, and one day she and I drove up the gorgeous curving Corniche road to the picturesque village of Eze, to scout out a restaurant for our player group of twelve.

Herb Caen, the famous San Francisco columnist, was on that Monte Carlo trip. I remember the day we arrived and were driven to our hotel. Our luggage had preceded us, and was stacked at the elegant entrance of the Hotel de Paris. Herb's leather briefcase, already filled with notes for his column, was right up at the front.

As Herb was about to get out of the car, along came a fancy well-dressed dame with her nose in the air and a cute little poodle on a leash strutting alongside, nose in the air just like her. The poodle sniffed Herb's briefcase and, in the briefest of moments, hesitated, lifted its leg, and sprayed.

"Well, I guess that's an expression of opinion," Herb commented.

As a traveling pro, I was accustomed to playing tennis with persons of limited skill. At Monte Carlo, Pancho Segura and I played with actress Penny Marshall (of LaVerne and Shirley fame) and Princess Grace of Monaco.

Pancho is a very humorous fellow, and he knows how to act up to make everybody happy. He teamed with the Princess, and obviously they won. I quickly diagnosed that Princess Grace's backhand was her weaker side, but her forehand was pretty good.

So that's where she got all the balls.

You do not defeat a princess on her own court.

*Match*

## 19. Passing Eighty

LONG PAST HIS PRIME, Fred Perry told me how nervous he used to feel before going out to play a tournament match.

"But then I'd look in the mirror and say to myself, 'Wait a minute. The other guy must be feeling more anxious than I. After all, he's up against the best player in the world—me!'" And he'd step onto the court, surging with confidence, and promptly clean his opponent's clock.

I give myself pep talks like that. I guess I must have played something like three thousand matches in five hundred tournaments in my life so far. Like a race horse, something in me hankers to get out of the starting gate and onto the track.

Not that I'm any Speedy Gonzalez these days. I'm told I have a sort of "hesitation waltz" to my tennis moves now. Rarely do I have the feeling that I'm in total control.

When I'm in trouble (as I often am), I fall back on my favorite screwball shots—the same that Gladys Heldman once referred to in her tennis magazine as "like dishing out a scoop of vanilla ice cream."

At sixty, I used to play down as many as three age brackets, taking on guys who were five, ten, or fifteen years younger than I. Now, in my eighties, I settle for one bracket lower. And even my own age group, which is a big concession for me.

You rust out faster than you wear out, I find. If I don't at least get to a backboard for a few minutes each day, my limbs let me know it.

I have a theory about keeping up with tennis at different ages of your life. For each decade, you need to play one more time a week

than you had been doing. For instance, in your twenties, twice a week is plenty to maintain your game. In your thirties, you need to play three times a week; in your forties, four times.

When you get into your fifties, you'd better play five times a week. And after that? Well, whatever you can do....

It's funny. In my first tournament as an eighty-year-old, I was the youngest player in the field! I see more and more guys taking up the game after retirement, really throwing themselves into it, like it's a new lease on life.

In St. Kanzian, Austria, at the international Gardnar Mulloy Cup matches for eighty-year-olds, a few of us sat around comparing notes about what tennis does for us. I found the chat insightful.

For Irving Levine of Rehoboth, Massachusetts, "There was a time in my life when I pretty much lost interest in everything. But when I found I had gained twenty pounds doing nothing, I got back into tennis pronto and the rest of my life fell into line. In a game like tennis, if you become reasonably efficient, never give it up. It's a gift that you have. I know in my heart I'll never be any great shakes, but I enjoy it. I thrive on it."

Gardnar Mulloy, that "grand old man" (he's been called that since he was thirty-five), was well over ninety when he said, "I've always found tennis interesting, a way to meet new people, a way to stay competitive. And it was a way to stay close to my father. Three times we won the national father-son titles. That was very enjoyable to me."

For Alex Swetka of Mountain View, California, "My most satisfying experience in tennis has been becoming the number-one player nationally in my age group ever since I turned sixty-five. I love to compete. I find it much more fun to travel for tournaments than to stay home to play."

For Mischa Stachowitsch of Austria, "Five times I was wounded during World War II. I still have shrapnel in my body. But that hasn't stopped me from going all-out for six different sports. Tennis I find the most satisfying. I hope to continue to enjoy it with the many friends I've met through the sport."

Walter Spiess, also an Austrian, said, "Tennis has helped me all my life. When I was a prisoner of war, I was assigned to fraternization duties because of my talent at tennis. This led to my being invited to come work in the states. Earning a living as a tennis pro enabled me to afford to get married."

Some Australians who were present chimed in, too.

Said Charlie Roe, "Tennis keeps me alive. I love it, because you can play to any age and get a game easily if there are two or four of you. It has great social advantages; you meet so many people. It's a way to stay fit. You lose weight, you get good exercise, and the friendship aspects are terrific."

Neville Halligan confided, "I've always loved tennis, but I never achieved much in it until I was seventy. I started taking lessons when I was fifty-five. I honestly feel you get better as you get older."

As for me, although I've had a lot of injuries because of tennis, I find the sport essential for maintaining my health and lifestyle. My serving capacity has gone from alarming (as it once was) to impotent. My legs, with one new knee added to the equation, don't run the way they used to; I'm always aware they might tangle up.

I see glimpses of proper play in myself, but plenty of improper also. I am working on pulling the edges together.

But what the heck. I don't have to be a champion in every division I pass through. I don't hold myself up to the standards of perfection that I had when I was eleven. (Or twenty-three. Or thirty, forty, fifty, sixty or seventy, for that matter.) Then, I wanted to be as good or better than anybody. I don't have that desire anymore. In fact, mother nature won't allow it. I just hope to keep on playing as long as I possibly can.

No more competitive tennis would not mean the end of the world. If I can just get out there and play with my children and grandchildren, play in a few club tournaments, or play with girls in some hit-and-giggle tennis and then go have a drink later, that would be fine.

I try to stay reasonably current. Why does life have to be all or

nothing? It can't be. Once you pass your prime, the odds are exceptionally high against your being at the top of your sport anymore. Now, if the tennis age handicap were to be set old enough, say ninety-seven, and nobody else is living, then maybe you could be a world champion.

Did I ever consider taking up golf? you might ask. I like golf as a game, but it takes too much time, and I don't have that much time left to learn and practice and work at being good at it. And if I can't be good, I'm not interested.

My youth has gone. But the beat goes on. And it sure is fun trying.

## 20. Keeping Healthy

I'VE BEEN ASKED if any injuries have slowed me down and threatened to end my tennis.

They sure have. Repeatedly. Thanks to the help of good luck and my own willingness to work hard, the problems were overcome.

When I was a boy of eight with a newspaper route, I was hit by a car. The handle of the door ripped into my eye. Fortunately, the driver was not a hit-and-run. He bundled this soggy little bleeding mess into the back of his car and sped to Emergency. Mother was summoned, and the doctors set to work stitching the eye—without anesthesia, yet! They had to hold me down. Mother was perhaps more scared than I was. "Don't worry, Mom," I'm told I said. "There will be times like this."

Somewhere around the age of twenty-five, I tore my right hamstring playing a finals against Whitney Reed at Golden Gate Park. The courts had just been resurfaced and were tacky. That's usually an advantage to a retriever, as I was then, because you can develop extra speed to chase the ball. But there was dust on the court, and as I put my right foot down hard and was digging in for traction, my foot just slid and I went out of control.

I was carted off to Emergency, given a painkiller, and told to walk around and get my badly torn leg back in shape. Which I did. Don't doctors know best? Wrong. The main ligament that goes down from the pelvic bone had ripped away (I later learned) from its mooring. In time, the remaining short hamstring attached itself to the other. Never had surgery for it.

When I was twenty-six, I was rear-ended while driving alone in

San Francisco. There were no seat belts then. My car spun around and my head went through the windshield. I pulled myself out, looked around to see if the car was damaged, and noticed my right ear was bleeding. It was, in fact, practically severed. Another trip to Emergency, where I was told I'd have to get my own surgeon to stitch me up. A fellow member from the Cal Club, Dr. Elwood Olson, did the honors. Very neatly too. The scars are chiefly around the back of my ear.

Still in my twenties, I developed Dupuytren's Contraction in my hands. It's an internal thing where the tendons harden and develop plaque which pulls around the cartilage, shortening it and pulling the fingers in like a claw. The remedy was, again, surgery, opening up the middle of the hands, shaving away the cartilage and binding them back together. The surgeon did a marvelous job, but it hurt like hell when the nurse in his office took out the stitches.

Then there was the time I dislocated my foot, playing with Margaret Osborne in the Pacific Southwest Mixed Doubles. A ball had been hit short to her left, near a fence. I was a brash teenager then, and sure I could get to the ball faster than she. So I took off running like Kim Clijsters, but took a misstep and went straight down on my left ankle, tearing every damn tendon in the foot. We had to default. I was put in a walking cast and sent home, where, for the next six weeks, Mother had fits watching out the window as I hopped down our steep hill at high speed.

Not yet out of my teens, and in Los Angeles playing in the Southern California Singles, my shoulder began to hurt from much wear and tear. I could hardly rotate it to serve or hit a decent forehand, and in desperation went to a chiropractor whom some of the boys recommended as having helped them.

He was an old geezer, sixty-five maybe. He put me on a rotating table with my rear going one way and my top half the other. He grabbed my hips. "Hey, doc," I said. "It's not my hips that are hurting; it's my shoulder."

"Never mind," he barked. "Your shoulder will be better when I get

through with it. I have to get your body lined up first." He finished with my lower region, went up to my head, and crunched the neck. I feared this greatly, but it didn't paralyze me. "Am I going to be better, doc?" I asked. After all, I had my career on the line.

"Yup," he said. "It's better now, and the more you play the better it will get. Go ahead and serve as hard as you can. You won't be able to hit very hard at first, but it will get better. Come back tomorrow at four o'clock."

So I played the next round of the tournament. It was pretty sore serving at first, but soon it got better, the motion was freer, and by two days later I was serving well and without pain. I coasted into the finals, and won it. From that time on, I have never pooh-poohed anyone who has an offbeat approach to helping. I am always willing to give them a fair trial.

You have to accept a lot of mishaps if you're going to get any-where in sports. Finally, my shoulder gave out on me. For years, I'd take a fistful of aspirin before a match. With each motion of the serve, the bone in the shoulder would grind away until eventually there was just powder in there, and chips, and hardly any room in the socket for the bone to move. It was like forcing a broom handle into the hinge of a door. The door wouldn't open. Pretty soon I could only hit a ball with a pitty-pat motion, and there would be consider-able pain. Sometimes I would even serve underhand. And then I got allergic to aspirin. It was obvious I'd either have to have a new shoul-der, or quit the game.

Quit the game? Never!

Enter my hero, Dr. Charles A. Rockwood, Jr., of the University of Texas Health Science Center in San Antonio. He's a pioneer surgeon in complicated shoulder problems. I flew down to see him in 1992. "That's the most sickening sound I ever heard," he remarked, manip-ulating the shoulder at my exam. "That shoulder is shot," he de-clared, which wasn't exactly news to me.

But I wasn't quite ready for an operation. I wanted to do one more tournament season, just in case there wouldn't be any more....

In February of 1994, I returned to San Antonio where Dr. Rock-wood performed a hemiarthroplasty procedure. It's an unusual oper-ation. A titanium spike is put in a reamed-out humerus and attached to a cobalt alloy ball that turns in the socket. I believe I'm the first tennis player in the world to have it done. And it only took forty-two minutes.

"Do you think I'll be able to play tennis again?" I asked him.

"Ah don't know," he said in his nice, warm, folksy Texas accent, "but ah think so."

Only one night in the hospital, and I was sent home with a sling. "Do I have to wear this?" I protested. "No, you don't," he told me. "It's just to keep people from runnin' into ya."

The rehab was left mostly up to me. I was given a set of five rub-ber ribbons—blue, green, black, red and yellow. I'd tie them to a doorknob and pull against them, like pulling my arm back to hit a forehand. At first I couldn't do it, but I practiced morning, noon, and night and pretty soon I could pull the operated shoulder up good and far.

I entered a tournament with a wide variety of age divisions and set about playing for practice about a month beforehand. I did as much as the shoulder would allow. Found I had to take a bigger swing and use a bit more arm than before. No problem with the backhand. I would just meet the ball with my body, and hit a pretty good stroke. The other players figured that my backhand was the way to get to me, but they were wrong. I went through the tourna-ment in straight sets. And won it.

And then came time for the left knee to have attention. It had been bothering me since my early forties and had gradually bowed out, but it had only been hurting seriously since I turned eighty.

I waited because I'd heard of knee surgeries that had turned out badly, or hadn't helped the player much at all. Also, I had a healthy mistrust of doctors, a mistrust that had built up over the years.

But when I started reading and hearing about knee replacement surgery, and seeing other tennis players who'd had it done and had

surmounted their post-surgery difficulties, I got the idea I'd like to do this, too. If they can make a go of it, so could I.

King Van Nostrand of Florida and Gene Scott of New York were very helpful, sharing their experience and advice. Gene had had double hip surgery in his late forties, and come back to win a number of national titles. King had had both knees replaced in 1997 when he was sixty-three. Five months later he won a sectional singles tournament, and in 1999 won the national clay 65s. He's been on a tear ever since. In 2004, when he was seventy, he was named the number-one player in his age group in both the U.S. and the world.

Inspired by these two, especially King, I had my knee replaced by Dr. Christopher Mow of the SOAR (Sports Orthopedic and Rehabilitation) Clinic of Redwood City. The operation was done at Stanford University Hospital. It was an efficient operation, but, as of this writing, I'm not completely satisfied.

If I were to be asked what advice I have for surgeons and physical therapists dealing with tennis player patients, I would say "Be honest. Talk freely, fully, and openly. Acquaint us with the risks, and what we'll have to do to get the most benefit from our surgery."

I didn't know, for instance, that the tendon below my knee was likely to tighten up. And I was not forewarned about balance. I damn near fell over in the beginning, trying some easy rallies at the backboard.

It took an old friend from the Golden Gate Park of my boyhood, Dr. Theodore (Ted) Myers of Hillsborough, California, to get through to me that I would never get my full balance back until certain of my nerves healed that had been cut during surgery. I would have been a heck of a lot less frustrated in the rehab process if my surgeon had told me that from the start.

As for you tennis players with hurting knees considering whether or not to have a replacement, you have to make a judgment for yourself as to the amount of tennis you're going to want to play. You should ask the doctor his opinion as to whether or not he can improve

your condition. How soon will you be able to play? Will you be able to play tournaments or not? You may have to press for answers, because doctors, typically, tend to hold back information.

My theory as to rehab is do the type of exercise, play, and competition that you're going to want to live with later. I asked my therapists for specific moves that would help me get back on the courts sooner. I found that they were delighted to oblige and break away from the routine drills that they give most of their patients.

To recuperate from a knee replacement, you have to use it. As soon as you're cleared by your surgeon to stand and walk unassisted, I recommend that you get yourself to a backboard. You will soon learn how faulty your balance is. Keep at it, without forcing yourself too much. Work up to hit with real people as your personal capability allows.

The best way to protect against your own weaknesses, I find, is to do damage control. I have to keep telling myself not to dwell on what used to be, but to know my strengths and carry the battle to the other fellow.

No matter what your age, I think you should always have a game plan.

I'm not back yet. Maybe I never will be. So I'll make do with what I've got, and we'll see how it goes.

Tennis, they say, is a game for a lifetime. And it's never too late to begin.

Right?

# 21. This and That

I WAS MUSING the other day about how tennis got started. It's come a long way since noblemen and knights in 1325 in Italy played an antecedent called "tenes." (Presumably, the knights played without armor.)

In that renaissance era, the racket was shaped rather like a zither. (One of my favorite tunes is "The Third Man" theme, so I can relate to that.)

In 1435, about twenty years before "goff" became the rage in Scotland, a game called Jeu du Paume (literally "game of the palm of the hand") was popular in France.

In 1522, Great Britain's King Henry VIII took Charles V of France as his doubles partner in a documented game of "tennice." Several courtiers rotated as opponents. According to a quite remarkable reference volume, *The Ultimate Tennis Book: 500 Years of the Sport,* by Gianni Clerici (Follett Publishing Co., Chicago, 1975), Henry's game ended with a tie at 11–all. Guess nobody wanted to lose a head.

At Hampton Court, in 1529, the first known detailed drawing was made greatly resembling a tennis court of today. Funny: the dimensions haven't changed much. Then: 29.29 meters long, 9.77 wide. Today: 23.77 meters long (78 feet), 10.97 wide (36 feet). And, boy! Does Roger Federer have a rapport with every single inch!

Back then, you could take as many serves as you wanted, without penalty, until a ball got into the designated area.

And players only changed sides once, at the end of each set.

The quaint way of scoring—love, fifteen, thirty, forty, deuce, et-cetera—was adapted from Court Tennis, which was played indoors across a net that originally was only one foot, eight inches high. I like that old scoring system. It's traditional. My learned friend, the late Gene Scott, was a devotee of Court Tennis, who helped make sure that it remained a nationally recognized U.S.T.A. championship. (He won it five times in the 1970s.)

The balls: they used to be fearsome things. Hand-sewn flannel covers wrapped tightly around a glob of feathers and sand. Or dog hair.

The server was once required to straddle the baseline. (How today's foot faulters would have loved that rule to continue!)

The costumes have sure changed. From pantaloons and doublets to the beachboy-like Capri pants of Rafael Nadal, or hardly any pants at all (thinking of today's leggy young Russian women players).

The sport just sort of puttered along until Major Walter Clopton Wingfield. In 1873, only forty years old, he had just retired from the British military, was understandably bored, and was casting about for an interesting new sport.

Croquet was the genteel sport then. But it was too slow for him. He loved the concept of a lawn game, but wanted a more active game to offer guests at his country estate.

And so he invented one. "Sphairistike," he called it. The Greek way of saying "Lawn Tennis." He dug two posts in the ground about twenty feet apart and stretched a long net, five feet high, between them.

He drove pegs into the ground marking the playing boundaries along the sidelines and baselines. He did a hand mailing to friends announcing and explaining his amusing new sport. He even took out a patent on his game.

Lucky thing, because it took off like wildfire all over the world. But nobody (except a Greek) could pronounce "Sphairistike," so Wingfield changed it to just plain Tennis.

According to a photograph in *The Ultimate Tennis Book,* Wing-

field was a dashing figure in his jaunty cap and mutton-chops and mustache. My lady friend, Lee, a former golf writer, is struck by Wingfield's resemblance to golf's early hero, Young Tom Morris of St Andrews, Scotland. The men lived, she tells me, at about the same time.

Wouldn't you know—it took a woman to introduce tennis to the United States. Mary Ewing Outerbridge tried the game while on vacation in 1874 in Bermuda. She brought home to Staten Island, New York a net and the requisite rackets and balls. Her brother, who owned an athletic club, set it up. And the game was off and running.

The All England Club at Wimbledon introduced the first serious tennis competition in 1877. The height of the net then was three feet, three inches. (It was raised to its present three feet, six inches in 1883 in order to make rallies and serves more exciting.)

Umpires are traditional to the game. They used to sit in a plain chair by the net post at the middle of the court. Must have been pretty uncomfortable. Also, the view of play was not good. So umpires were promoted to a raised chair up a ladder. Over time, a footrest was added. These flaps could be a menace. I know. In Portschach, Austria, I was passing beneath the umpire's chair at a break when a footrest fell down and struck me on the head.

In 1878, the first recorded tennis match in the U.S. was played in Nahant, on the north shore of Boston, Massachusetts. The first Davis Cup challenge round was held in 1900, at Longwood Cricket Club, near Boston. Not to be outdone, women came up with the Wightman Cup in 1923.

I was born in 1922!

So there you have it. Tennis' origins in a nutshell. Only the equipment has changed, really.

Balls are still wool covered, with neat seams glued in to keep them in one piece. I favor the Dunlop ball. Seems to me their seams are more even and flatter, and they help the ball bounce truer than the other balls available.

The insides of balls are no longer stuffed with mishmash. They're

hollow—inflated to the legal limit with sodium nitrate and chloride of ammonia. Thus, the hiss and the unmistakable gassy odor you get when you open a fresh can.

Metal rackets, by the way, are not new. They've been around since 1930. Rene Lacoste perfected the idea in 1965, improving the balance and making the center of gravity more stable. The sizes of today's racket heads are, to me, ridiculous. In my opinion, an oversize head is cumbersome. It goes through the air more slowly, and time is important for most of us. A medium-size racket is good enough for me.

Linesmen: In the old days, I would have bet my young eyes calling a correct line over a courtside camera. But not now. Not when the balls fly back and forth so fast and hard, searing the lines, blurring the chalk on grass courts. I think the new instant replay machines are marvelous for overruling bad calls.

Prize money: I'm all in favor of prize money being out in the open now. I only wish they hadn't left me out. I'd have loved some of the pot! Knowing a player is playing for really big bucks at stake creates more public interest in the sport.

TV cameras: Certainly, a player feels a little nervous knowing cameras are focused upon him (or her). Your image (and goofs) are instantly transmitted all over the world. TV coverage has changed our game dramatically, and for the best. I really feel my sport would have died without it. $$$$$$ sponsorships mean lots more spectators.

Court surfaces: I totally agree (for once!) with the U.S.T.A. that our four major national tennis championships should be played on all four of the recognized court surfaces—hard court, indoor, grass, and clay. The ultimate challenge, I believe, is grass. With its quirky bumps and grinds, a player must make full use of his wits, talent, athletic ability, and humor.

One closing thought here: Can you name the tennis player of some renown who survived the April, 1912 sinking of the *Titanic*?

Right! Richard Norris Williams II.

What a guy! He was born an American but grew up in Switzerland, where he became a credible tennis player. He was twenty-one when he boarded the *Titanic* with his father, planning to play some Eastern U.S. tournaments before enrolling at Harvard. They traveled first class. When the *Titanic* went down, his father was killed but Dick clung to a half-submerged life raft and was rescued by the liner *Carpathia*. His legs were in such awful shape, the ship's doctor wanted to amputate them. But Dick refused and returned to Europe in May to convalesce.

Before the summer was out, he came back to the U.S., enrolled at Harvard, and entered the U.S. Mixed Doubles. Which he won, with Mary K. Browne!

The very next year, he reached the U.S. Men's Singles finals and was named to the U.S. Davis Cup team, which he captained to six wins over thirteen years. In 1914 and 1916 he won the U.S. Men's Singles title. Then World War I happened. In 1920, Dick won the men's doubles at Wimbledon. In 1924 he was a singles finalist there.

He died at the age of seventy-eight.

Tennis players are tough.

## 22. Golden Gate Salute

WHENEVER I'M FEELING DOWN, I go to Golden Gate Park, San Francisco. Back to my roots, back to where my life in tennis began.

I never fail to revive my spirits there, watching people enjoying themselves. Within the park, which begins just a few blocks west of downtown and stretches for four and a half miles to the Pacific Ocean, people are biking, golfing, picnicking, sailing model boats, flying model planes, strolling through the Japanese tea garden, visiting one of the finest art museums in the United States, and, of course, playing tennis.

Golden Gate Park grew out of a desire of San Franciscans in the mid–1850s to have a public park the equal of Central Park in New York. There was to be a California Midwinter International Exposition in 1894, and the city needed a site for it. Early architects said "no way"—the area in mind was a thousand acres of barren, shifting sand dunes upon which, they thought, nothing could grow.

A Scotsman, John McLaren, rose to the occasion. Appointed in 1890 to be superintendent of gardening, he brought in lots of manure and began planting grass and plenty of trees and bushes to hold the sand down. To everyone's amazement, it soon became a great flourishing forest, complete with lakes and meadows.

The fair was successful, and then came the park's second serious test. The San Francisco Earthquake of 1906. Thousands of citizens took refuge there, and by their very numbers trampled many of the newly landscaped areas.

166—

But the park survived—bring in more manure!—and by 1907 eight tennis courts had been built—one for women, two for juniors, and five for men. By the time my parents discovered it, around about 1926, there were twenty-three courts. Today, there are twenty-one.

The twenty-second court was converted, largely at my urging as an adult, to a nice, long generous backboard, open for hitting at both ends. As many as six players can practice there at a time, without tripping over each other.

The Golden Gate Park Tennis Complex is at the eastern end of the park, near where Bowling Green Drive and John F. Kennedy Drive intersect. It's kind of kitty-corner from the Conservatory of Flowers. My favorite courts are one through four because they're close to hillocks and protected from the ocean winds that often sweep through the courts beyond.

A casual visitor might think the top court, number five, because it's boxed, is the most desirable. Nope. Very distracting there, with park people walking, jogging, skateboarding past it, and on weekends drummers do their thing on what's called Bongo Hill, making a helluva noise. Just beyond is Mother's Meadow, where women with babies park themselves for the afternoon. Assign me anything but court five!

As a boy, I enjoyed walking to the courts from our step-street apartment on Alpine Terrace. It was a nice workaday neighborhood then, but pretty crummy today. My walk led through the Haight-Ashbury district. Some thirty years later, that area won infamous fame as a hangout for flower children and pot smokers. Even today, the district is rife with girlie shows, tattoo parlors, pool halls, and graffiti.

I'd enter by the teahouse, near the carousel, next to the lawn bowling courts. (It's a step back into the past to come upon lawn bowlers still there today, dressed in their traditional ankle-length whites.)

The courts at Golden Gate Park were free for children, but you had to prove yourself. There was a sign to the effect, "Players must be ranked. No juniors." That sign didn't stay up long.

We kids considered it a challenge to get good at the game so that better players would want to play with us. For the park has always had a quaint privilege. There is never a charge for children and the court can be assigned in their name. Thus, if an adult is signed up with a child, the adult can play for free also.

It was always music to my ears to have an adult call me over and say, "Hey, kid, I'd like to play with you." And it gave me the greatest of pleasure when I was able to beat him fair and square.

Phil Sleeper, Golden Gate Park's director of tennis for the past twenty years, filled me in on the current scene. "Weekday traffic has really dropped off here," he told me, "but weekends you can't buy a court. What has really caught on fire is league tennis. We have twenty-two women's teams, let alone seniors', men's and junior teams, using these courts evenings and weekends. After three p.m. it gets a little crazy.

"We're the last municipal complex I know of where there are never any tennis fees for children, no tournament fees, no nothing. We simply try to get people interested in tennis.

"Our strength is making sure that any kid who wants to play can. If a kid doesn't have a racket, we'll give him one. We get a lot of donations. We keep a box of balls for them to help themselves to.

"Of course, we've lost a lot of color over the years that you'd remember."

"Ah, yes," I said. "Like old George, who loved to drink and toward the end of his life played a memorable match on court one for money, against an old hippie named Byron. They were both stoned to the gills and smoking to boot. They would stop, kibitz, shrug off their sneakers, have another belt, and maybe five minutes later take up the match where they had left off, playing beautiful flawless tennis. It was magic to me that they could be such slobs on the outside, and yet pull out of themselves a great game."

I remembered, too, Rosie the Streaker—a well-endowed young woman who, on a dare one sunny day, threw off her clothes and ran the length of the tennis courts. "Go, Rosie, go!" we cheered her on.

"Haven't had any excitement like that, lately," Phil smiled.

I asked him what his biggest problem is these days. "Court maintenance," he told me. "Because the park is mostly sand, it works up beneath the bushes, grass and trees, so we always have dirt and debris on the courts. We have a good staff, though, and use blowers on the courts every morning."

I asked what today's rates are. Free for children, I knew that. But for adults? "Two dollars on weekdays, six on weekends. That's per court, not per person, and court use is for one and a half hours." (At this writing, phone number for court reservations is 415–753–7001.)

Private club members in San Francisco are not averse to playing at the park. In fact, the park courts are in rotation with team matches between the San Francisco Tennis Club, the Golden Gateway Tennis Club, The Olympic Club, and the California Tennis Club. The twenty-one courts at the park got a $200,000 resurfacing a few years back, courtesy of The Olympic Club. A very nice gesture, I think.

The clubhouse, though, is less than adequate. A prominent sign says "Please—No Radios, Profanity, Dice Games or Sleeping." A bulletin board posts human-interest items such as roommates wanted, dogs lost, etc.

The clubhouse is named for William M. (Billy) Johnston, a legend well before I was born. Pictures of other famous Golden Gate Park players dot the walls—Maurice McLoughlin, Alice Marble, Hazel Hotchkiss Wightman....

And me? Didn't notice one, although between the years of 1945 and 1970, I won the city championship there thirteen times, and was finalist another four times.

Fame, it seems, is a fleeting thing.

Oh well, time to meander through the park, past the Dutch windmill, along the Great Highway, to have a drink at the Beach Chalet restaurant.

In the early 1900s, this was the showers and changing rooms for the outdoor ocean water Fleishacker Pool (no longer operating). Today, the Beach Chalet houses the Golden Gate Park Information

Visitor Center. Mosaic tile murals of personalities around the walls tell the story of San Francisco at the turn of the 1900s. Ask the lady on duty to point out who's who. There's even a tennis player (female) pictured.

Just up the Great Highway is the more glamorous restaurant, the famous Cliff House.

Another site of my early youth. Remember me telling you of the Sutro Baths, the rescue from the sea cave?

Please pause there, too.

And have a drink on me.

# Index to People, Places, and Institutions

*As Tom Goes By*